CASA COLOMBIANA

THE HOUSE IN THE TROPICS

Heat in the tropics is rather special. While the nontropical portions of the planet associate heat with summer, in the tropical lowlands, heat is a constant presence, accentuated by humidity during the rains, when it becomes oppressive. But tropical heat is vital, enveloping, and reassuring in drier weather. The temperature of the tropics is reflected by regional clothing, objects, plants, and architecture. There is a culture of heat.

In Colombia, the hottest regions lie along the two sea coasts and in the great river valleys, the eastern plains, and the Amazon region. Creating a cool covered area is the first order of business in building a tropical house, and the furniture and decor must both look cool and be cool. The breeze, some fairly shaded areas, plants that work as natural fans as they sway in the wind, and masses of greenery highlighted by the riotous colors of tropical flowers—all these are elements of comfort in houses set in what we call "hot country."

The traditional architecture of the tropics rises around a patio, where the specific microclimate of the house is created. A space both open and

private, the patio provides a breathing space as well as an interior setting for the house. The initial impression of a dwelling is the patio; you arrive there, and often that is where you sit. Trees and plants surround you with their green, cool presence, providing a soothing subtext of sound and movement as they respond to the land. There may also be water in fountains providing visual refreshment or pools that invite overheated bodies into their cool bliss. The patio is the confluence of architecture, domesticated nature, and wind and water, and all of this pervades the rooms of the house, providing respite in dry seasons from the burning, challenging land around it, or from the dusty city. When it is wet, the patio is renewed and cleansed by the rain and is a place where the dribble of the rain and the slow drip of water from the plants mark time, lazy time.

Terraces and balconies are other important elements in Colombian tropical houses. They are ways for the inside of the house to communicate with its surroundings. The balcony is the more controlled space; it protects your privacy and allows you to participate in the life of the street. The terrace is open to the sky and the view. It is a social space where a group of friends can meet or a party can be held. The terrace is also a solarium and at times a space that provides relief from stifling nights.

The doors and windows of a tropical house are not only openings in the walls made to create communication between spaces, they are also aligned to let air flow through the house. A language of ornamentation is expressed through them, too, creating a sense of intimacy. Marvelous styles of woodwork were developed to treat windows and doors. Transparencies and hindrances, openings and closures, are used to make the interior of the house cooler without the need for air-conditioning, which is efficient but impersonal and deprives spaces of their character.

The height of the ceilings is important in tropical houses. Traditional architecture obeyed a very simple environmental principle: the greater the volume of air, the cooler the room. Hot air concentrates in the room's highest area, and there openings are provided to allow the air to exit. The interior space of the house manages to adapt to the peculiarities of the

climate. The practical use of high ceilings created an important architectural presence, a particular scale. In these high spaces, the furniture and objects look different. Upon them, the architecture imposes itself.

The furniture of a house in the tropical hot country of Colombia is also a response to the climate and creates a special ambiance. The hammock, inherited from the Indians, is specially significant in a tropical house. Being light, it lets the breeze through. It is like a resilient fan, where one may rest or sleep. A hammock can also be an object of singular beauty, virtually an architectural feature. Wicker furniture is often part of the furniture of this type of house. It is furniture that breathes.

The Colombian tropical house is a natural factory for comfort. The rooms are ample, with the furniture sitting lightly in fairly unencumbered spaces, suggesting repose. People in the tropics move and work in their houses in what looks like slow motion, keeping cool. The tropical house invites you to be lazy, to accept gracefully the drowsiness of the hot noonday, to flow with the slow passage of time during the rainy season, and awake in the dry season to the light and mobile touch of the breeze. Nights, the house is populated by the memories of the day and the eloquent silence of sensual sleep.

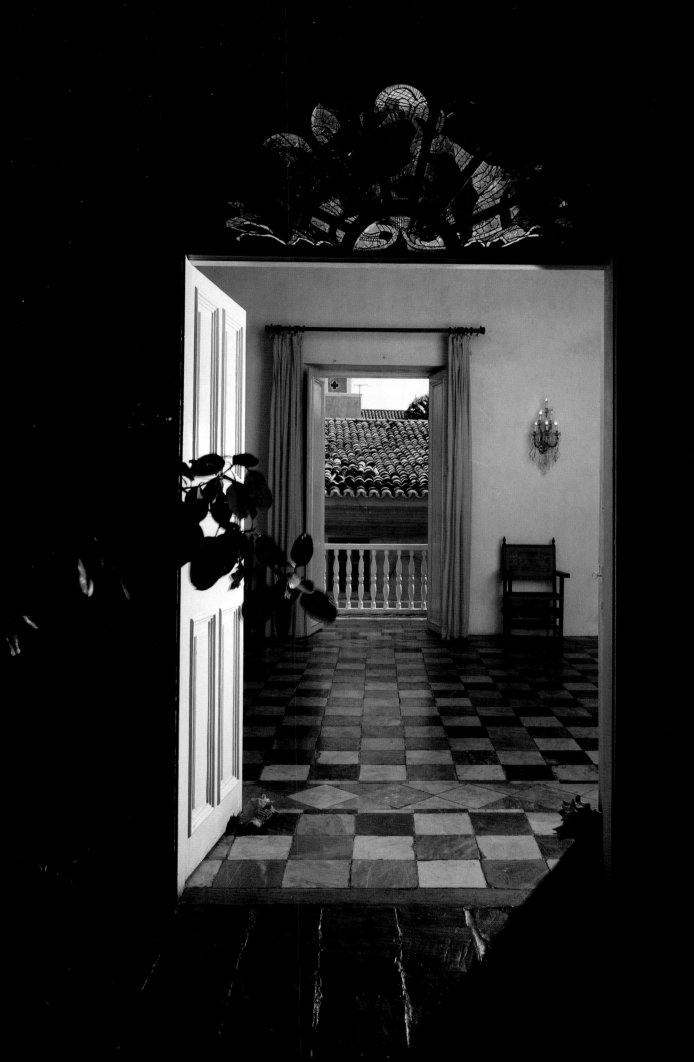

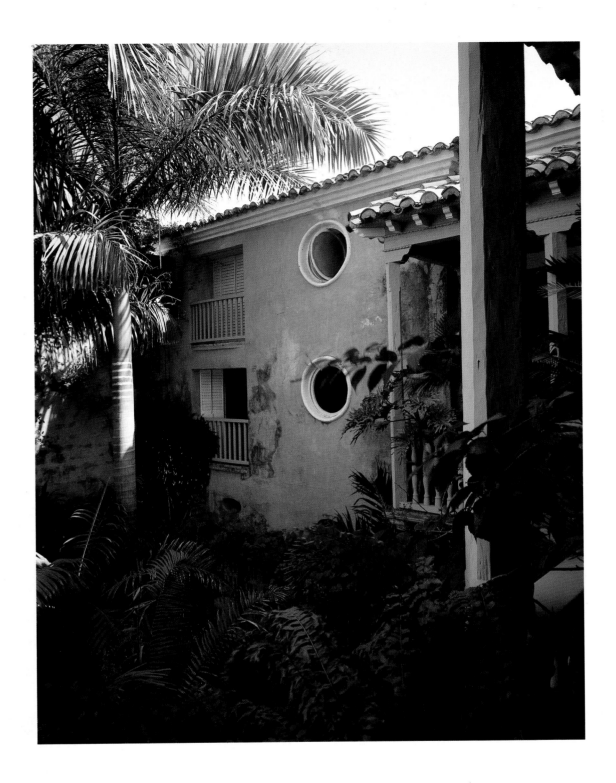

The architecture of the traditional house in Cartagena reveals its Mediterranean origin in the
importance of the main courtyard or "patio" and a.set of rooms arranged around it.
This introverted disposition matched the sense of internal cohesion of family life that came
to America from the south of Spain, where Islamic customs marked social habits,
urban space, and domestic atmosphere.

At the end of the seventeenth century, the
appearance of the tall house of two or three stories,
with a mezzanine facing the street and a terrace or a
high balcony at the back, lent dignity to the central
section of the walled precinct of Cartagena de Indias
and allowed greater play with a variety of open spaces,
ornaments, and structural elements. The size and
irregular shape of the properties prevented the
construction of an enclosed space over the central patio.
That is why the body of the house is generally L- or
U-shaped and leaves room on the border for the patio.
(Behind the hall on the second story, the wrap-around
continuous balconies display in the railing and in the
rhythm of its lathe-turned wooden banisters a version
of the European models in stone.) Color is treated in
various ways in the Cartagena house. Often the color
chosen for the main surface is white or ochre or pale
yellow, while projecting areas and ornamental features
are painted with contrasting colors.

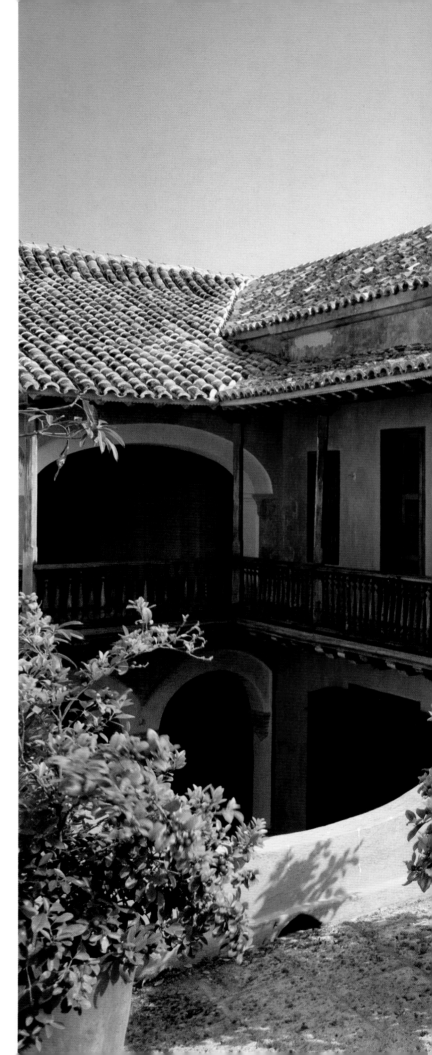

CARTAGENA, BOLÍVAR / CARTAGENA, BOLÍVAR (FOLLOWING)

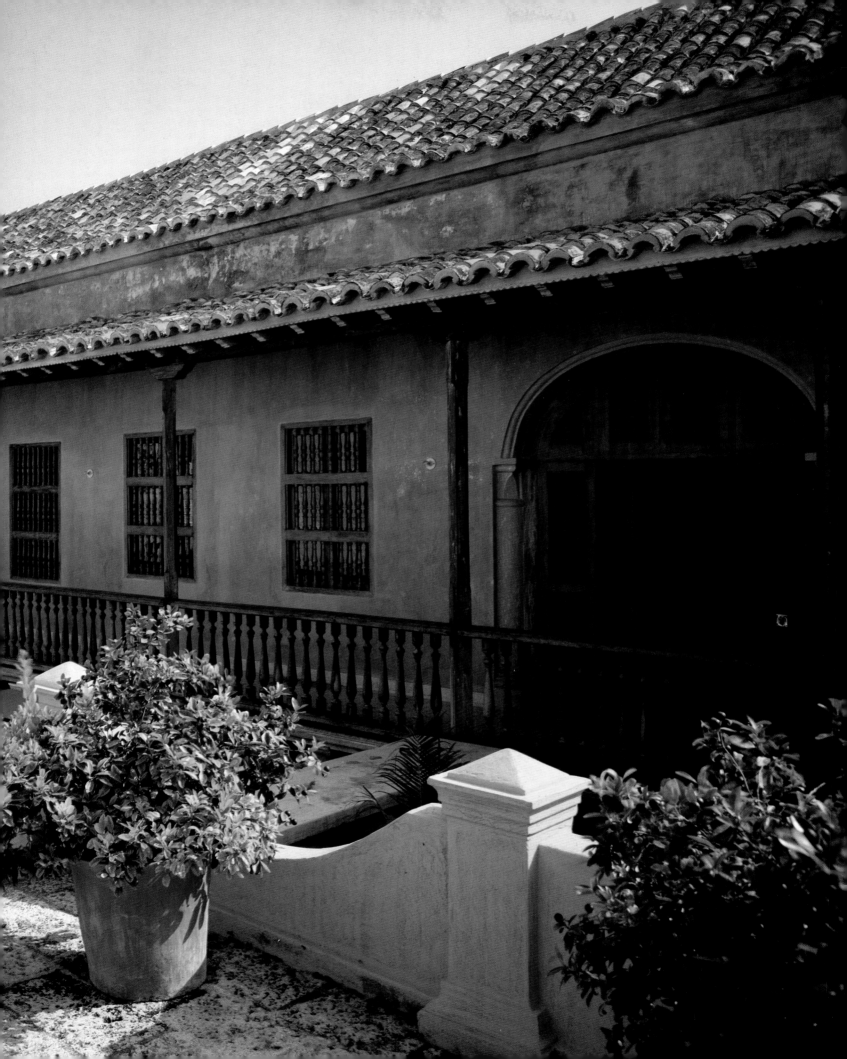

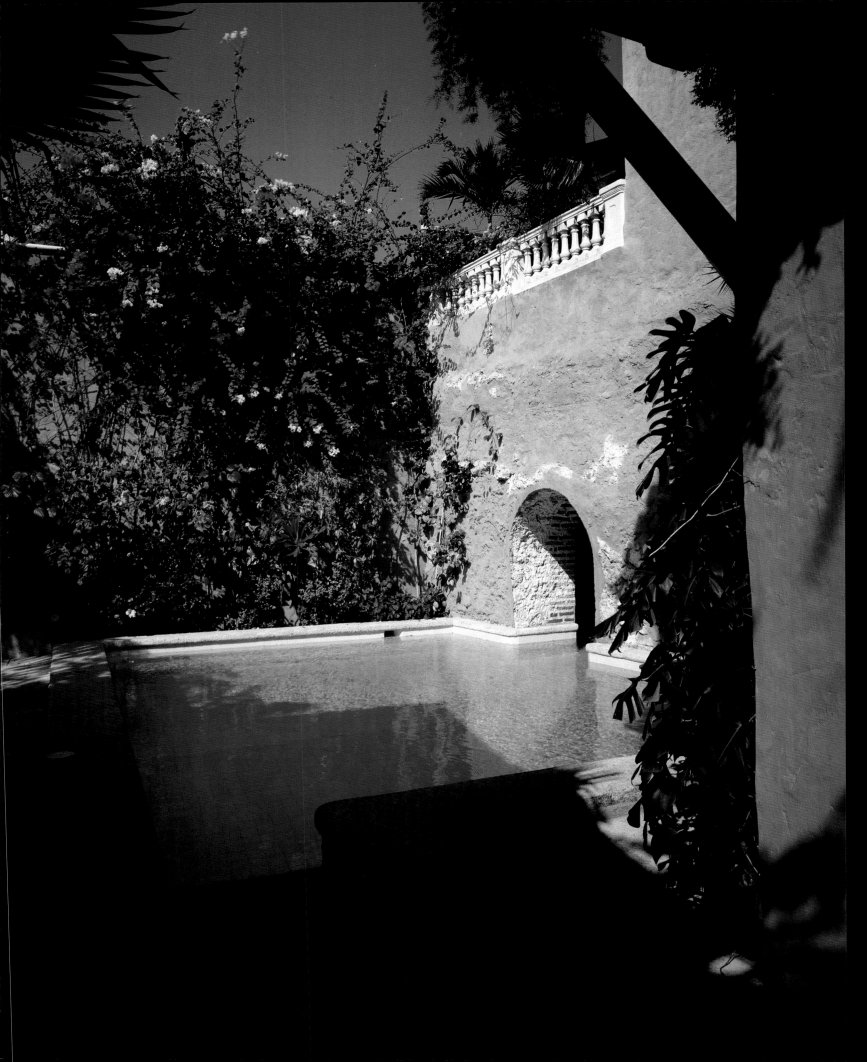

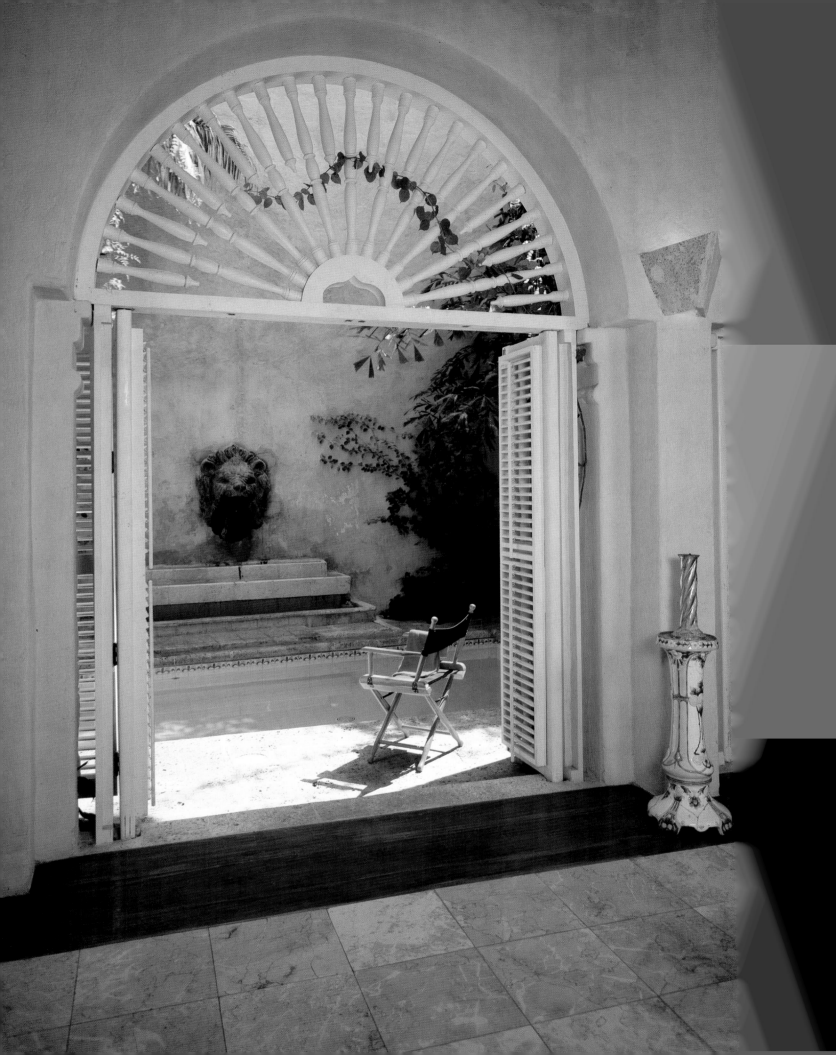

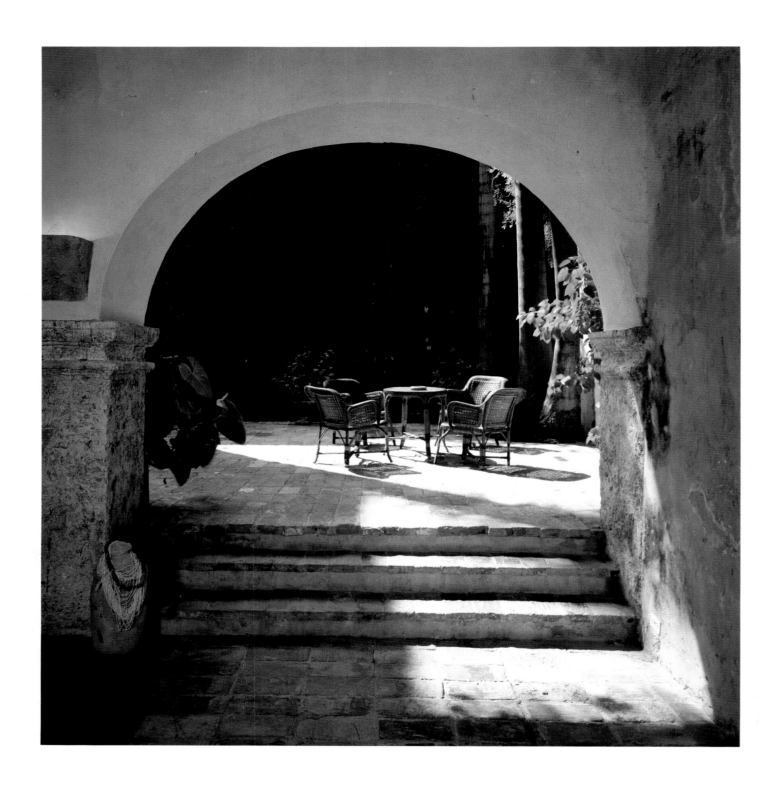

*Window bars, folding screens, and shutters between full light and shadow define the
degree of importance of the adjoining areas, of which the balcony is an extension over the street.
The arch sets off the hall, defines areas, amplifies the line of sight, and announces
the patio, elements that give the house an air of intimate beauty.*

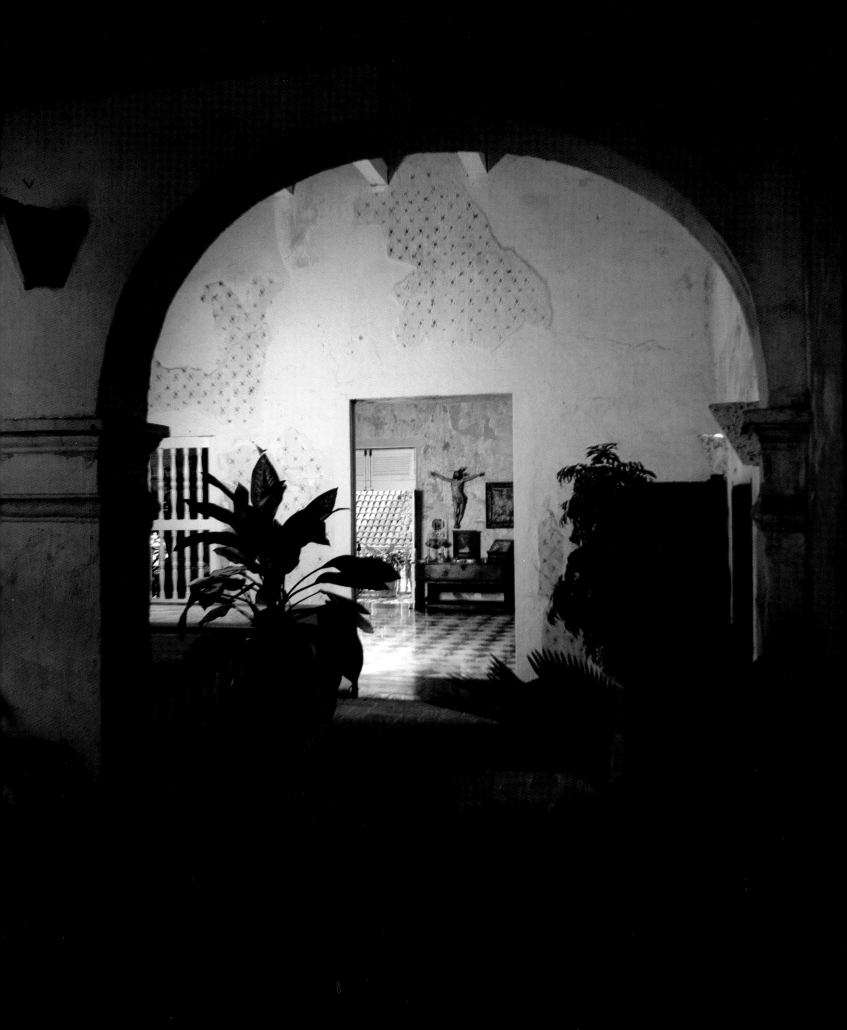

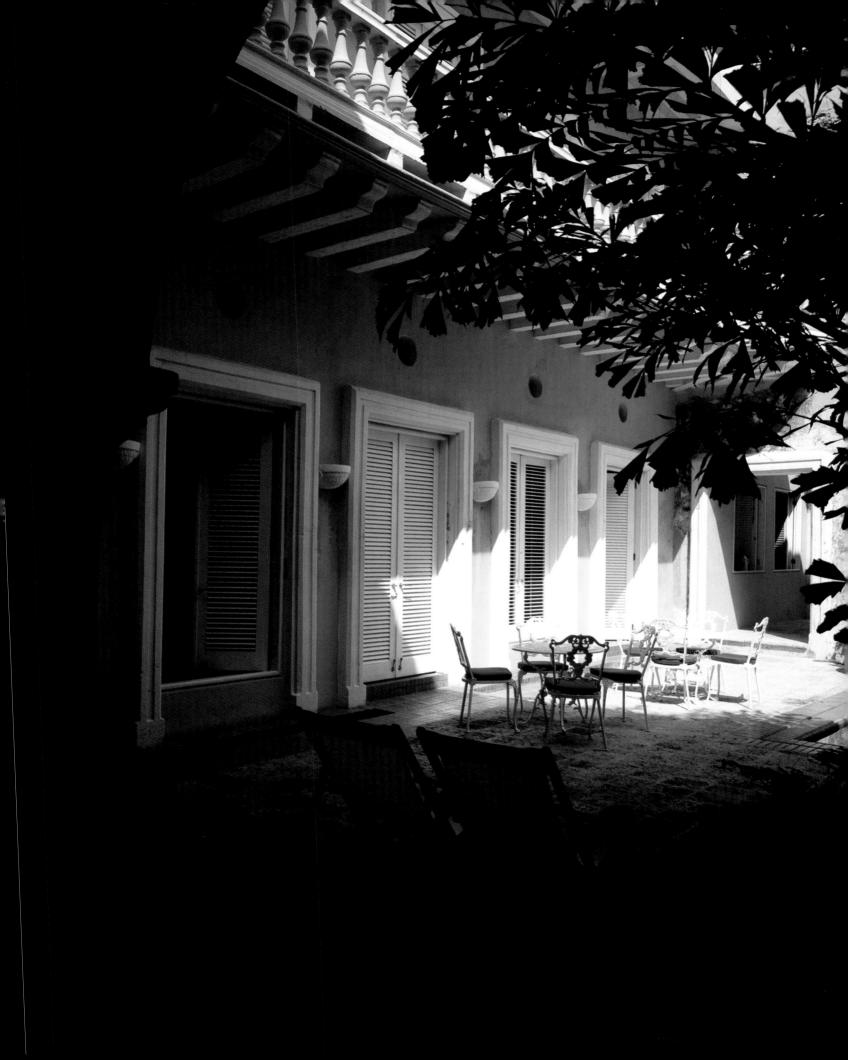

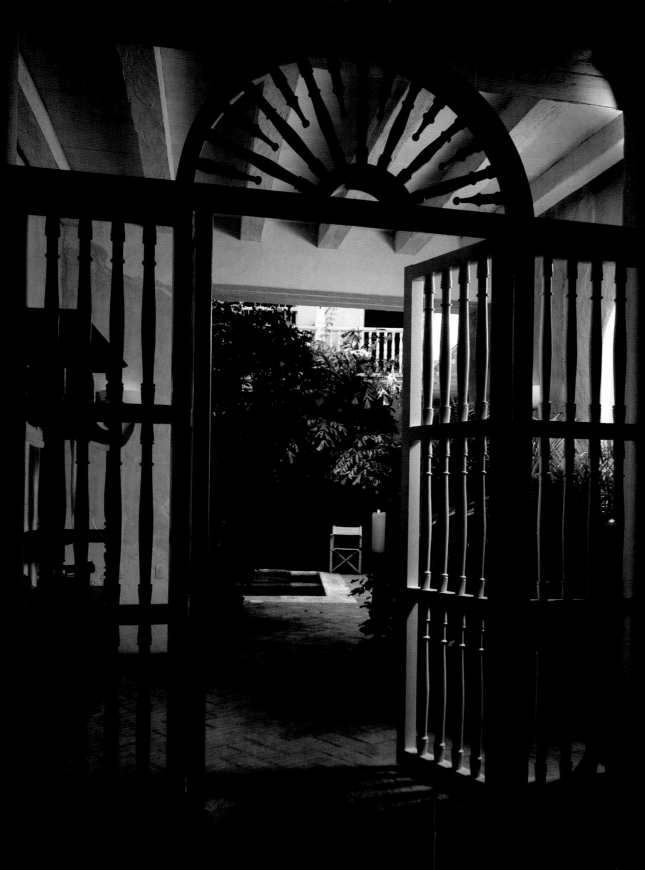

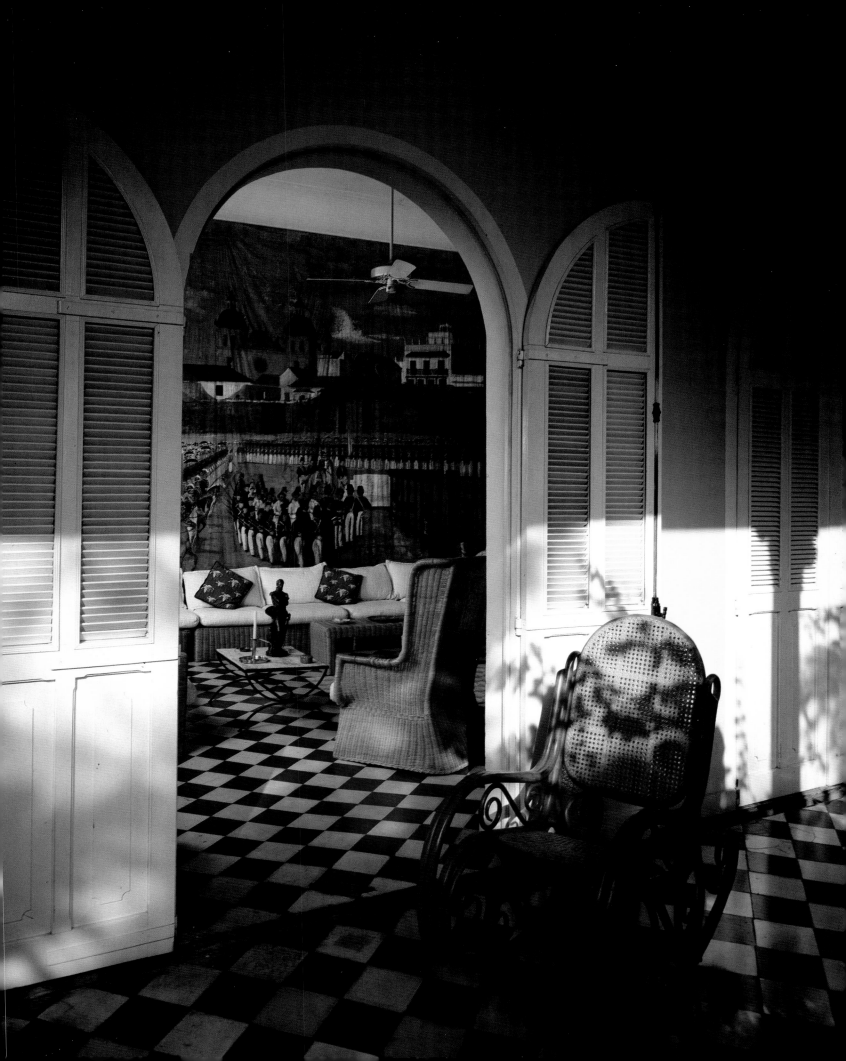

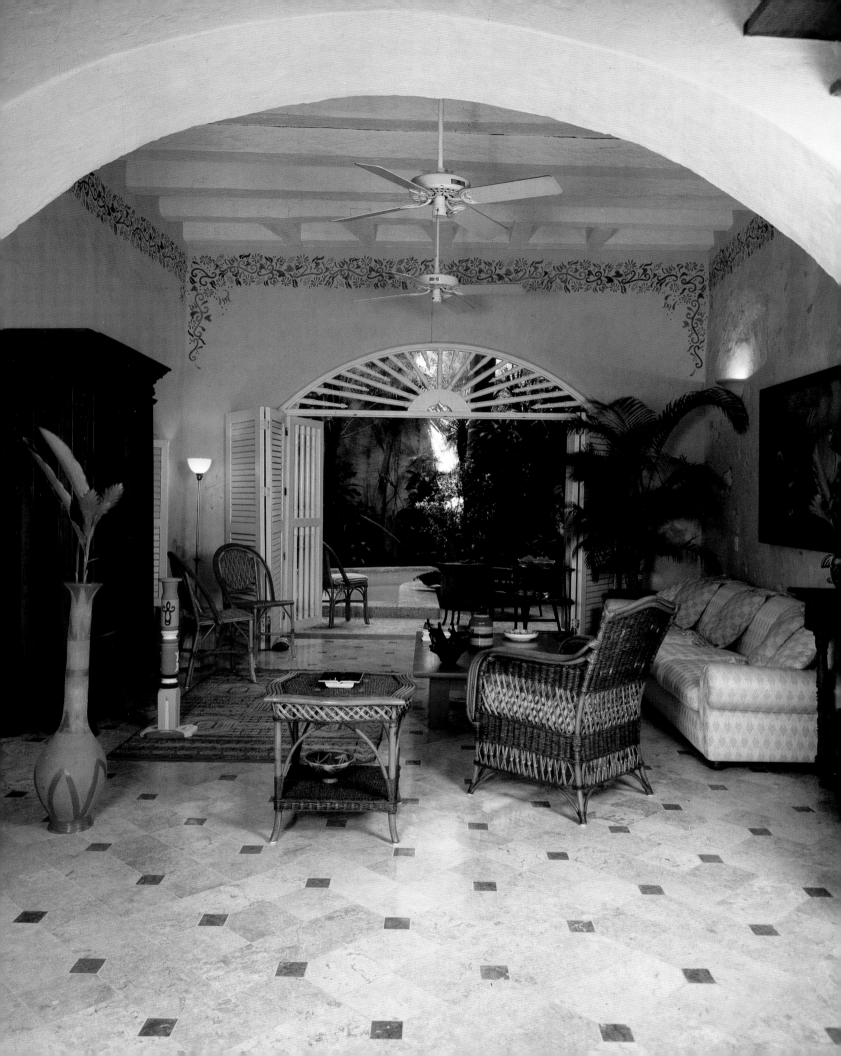

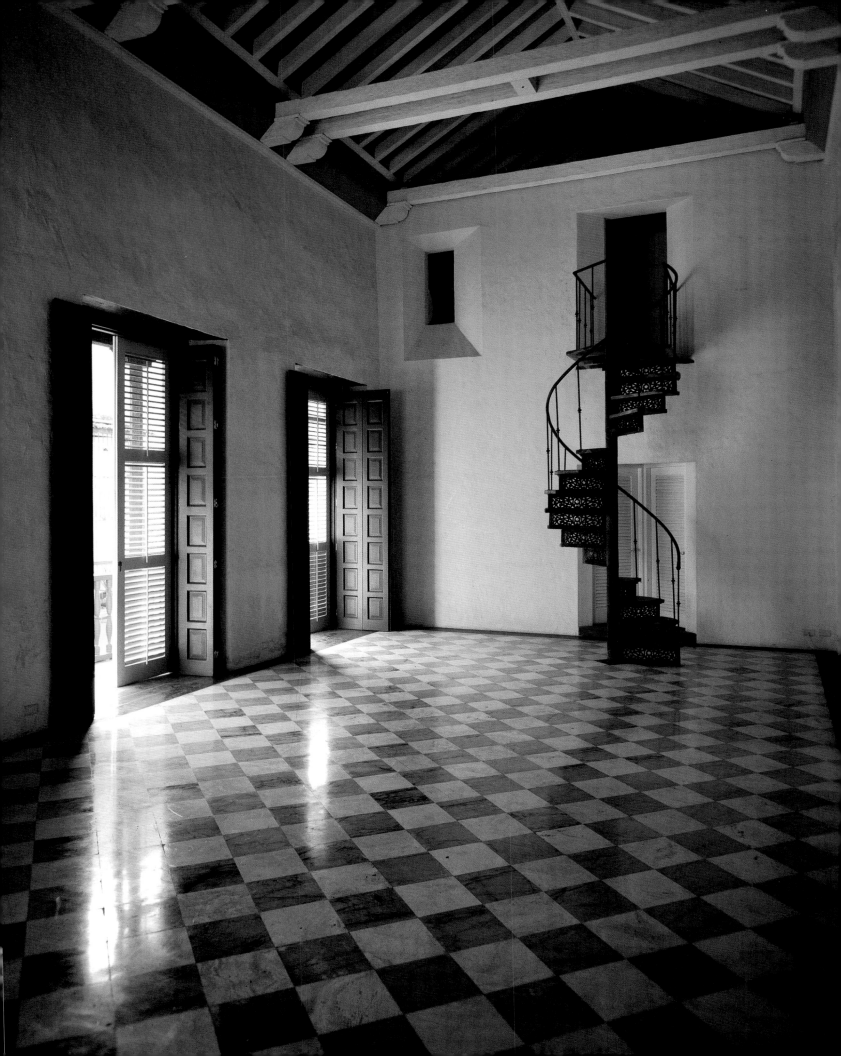

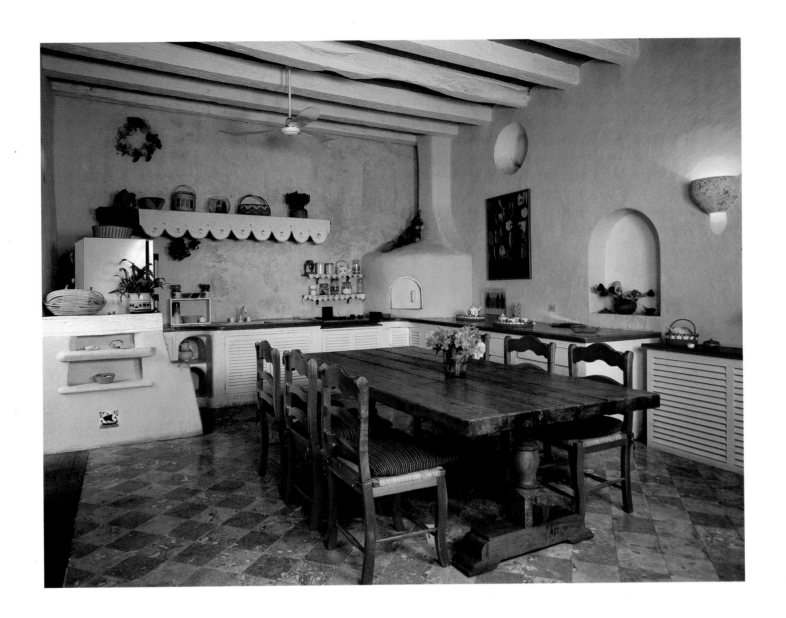

Domestic spaces in Cartagena's old houses are distinguished according to their function,
importance, and location in the general plan. In two-story homes, the high space of the
drawing room is placed in the front section of the upper floor and opens onto a balcony of
the same length. The roof structure of the room, with all its supporting elements, is left exposed.
In the same house, the kitchen and dining room are placed at the back of the house,
on the ground floor.

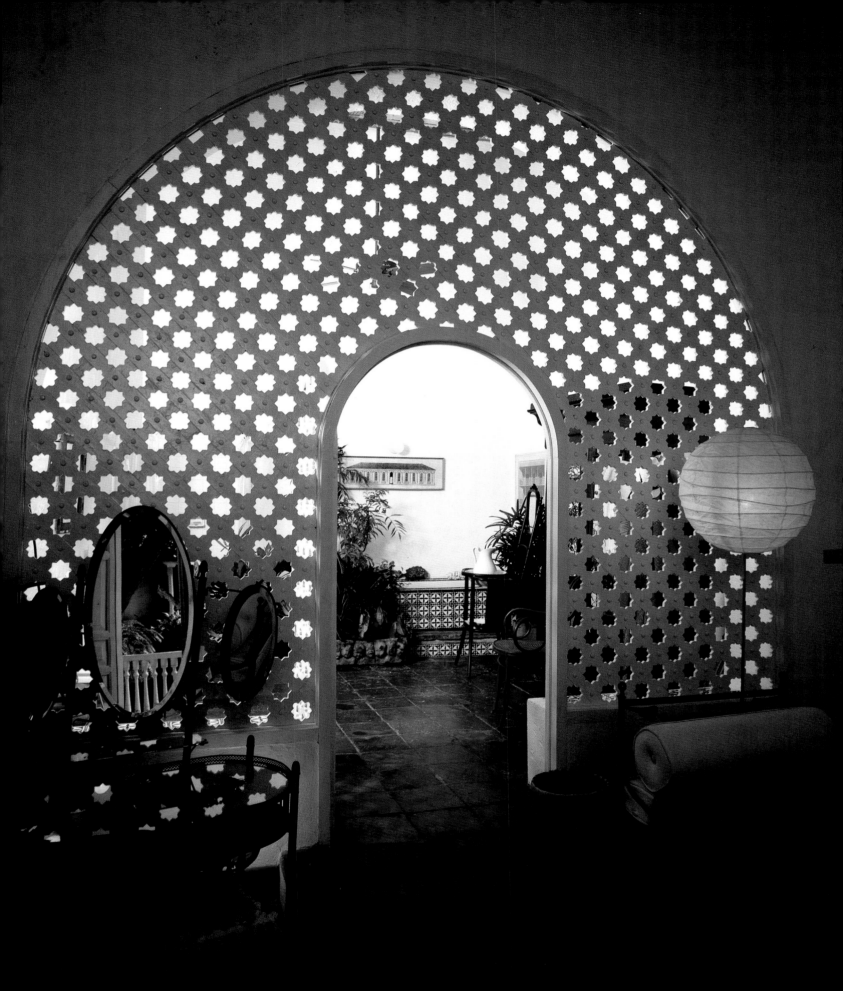

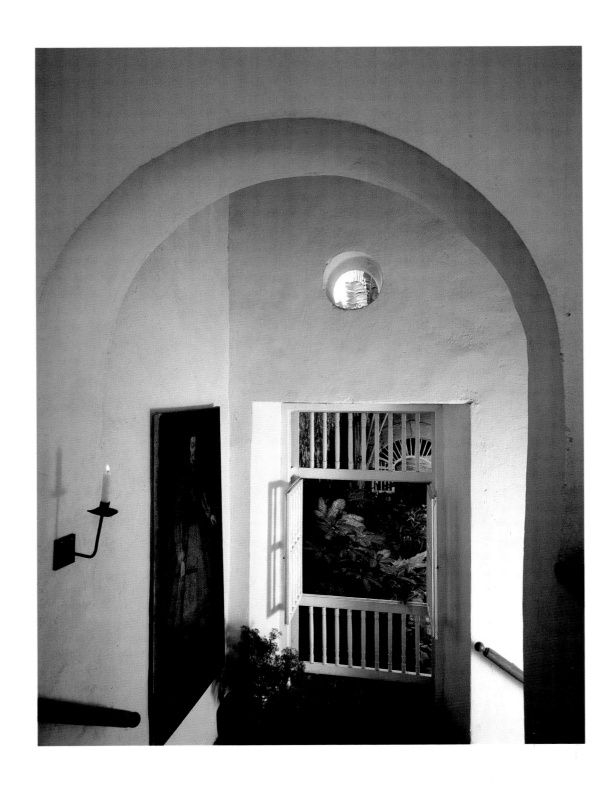

*Faithful to origins inherited from Spain, the house's sequence of rooms
begins with the entry, after which come the hall and the arcade, which looks out onto the patio.
In two-story houses, the stairs enjoy an architectural openness, in which, on reaching
the top floor, the light and the generous width of the stairway merge onto the equally ample
upstairs hallway, which offers from its arch the pleasant benefits of the view
and coolness of the patio.*

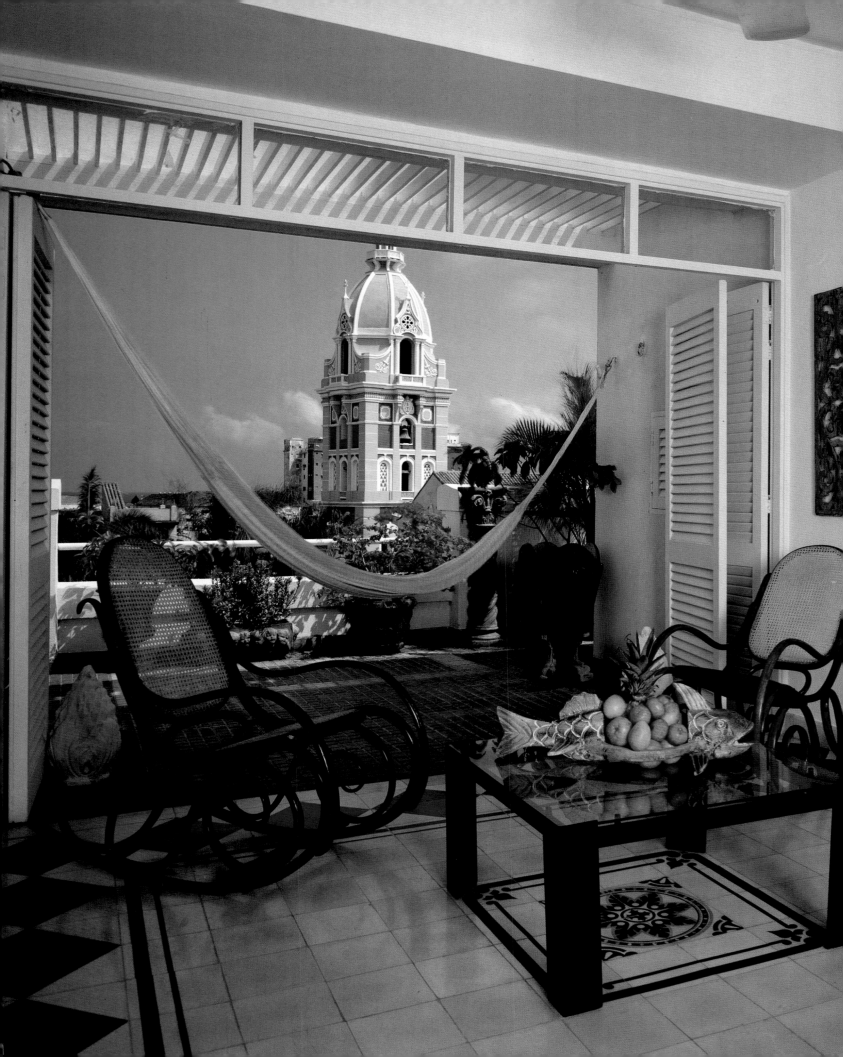

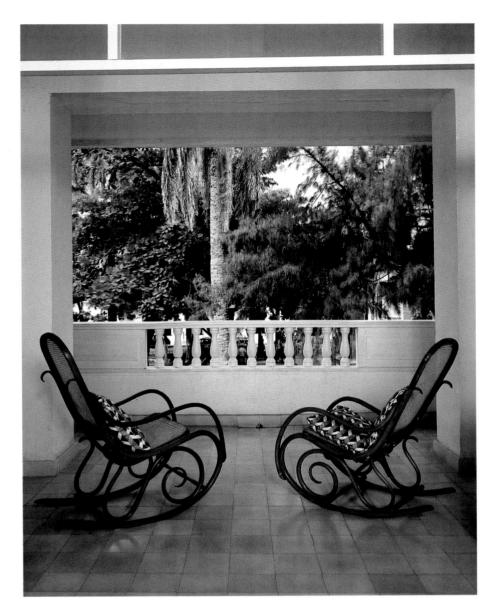

In Cartagena, as in most of the colonial cities of the Caribbean
region, there is a dearth of vegetation. Though rich in authentic
expression and in architectural and decorative elements, nature
has been relegated to the public square and, for intimacy,
to domestic yards. This feature has been respected in the works of
restoration within the walled city, but has been compensated for
by a great variety of tropical flora on the balconies and terraces
and in the bay windows.

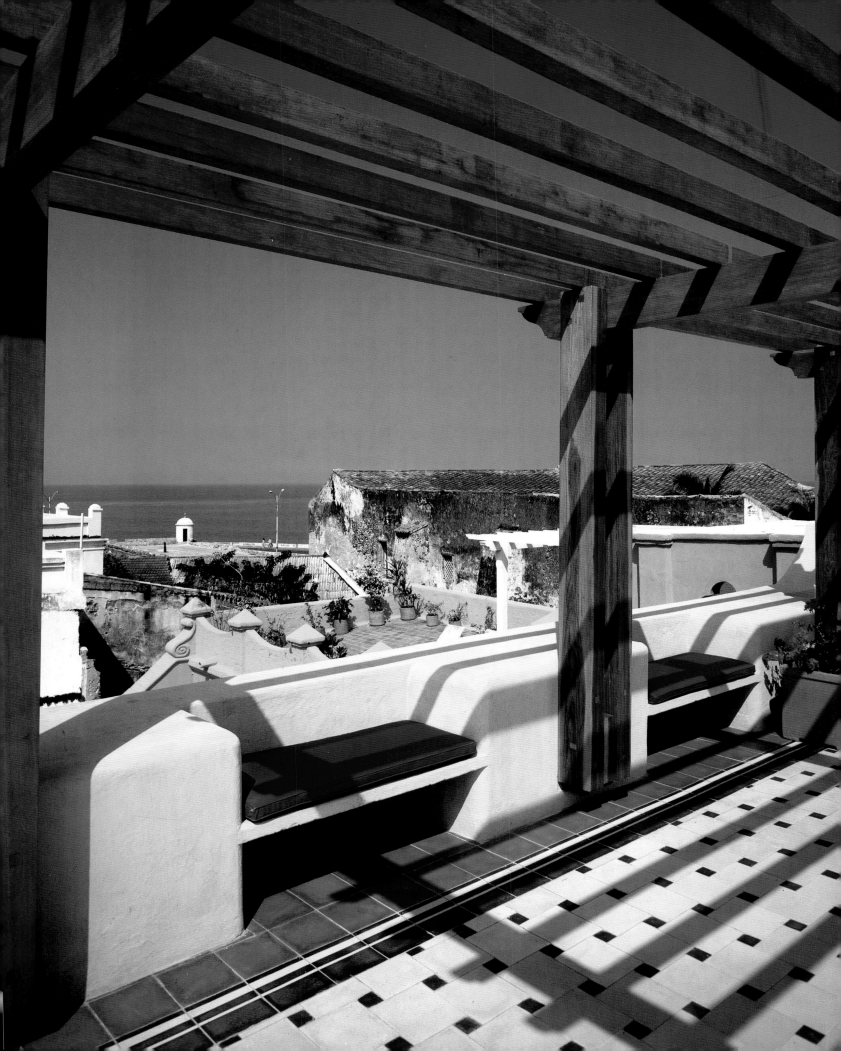

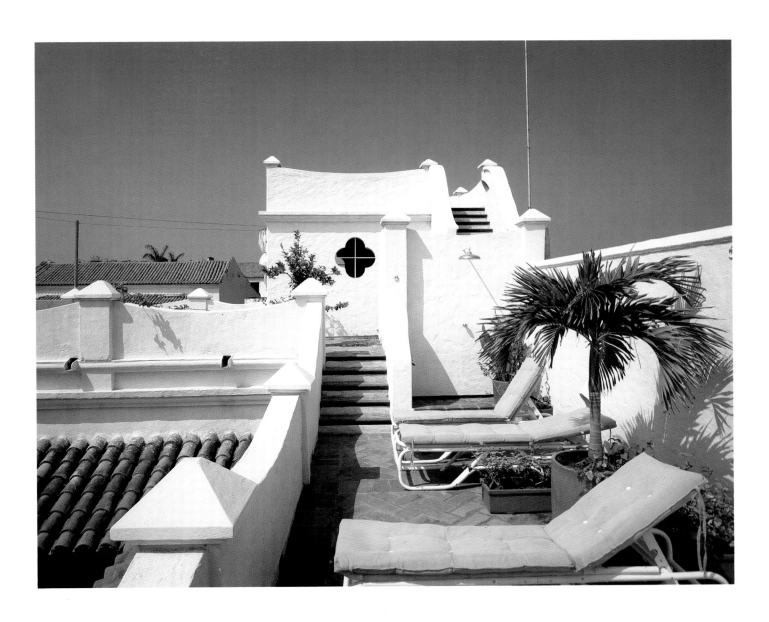

In the large houses in Cartagena, the mirador *or* belvedere, *a terrace placed on top of a
small tower, is a heritage of colonial architecture and a very valuable element.
It was originally used as a place from which to watch the arrival of ships—friendly or hostile.
Now it is a place for social life with wonderful views of the city and the sea.*

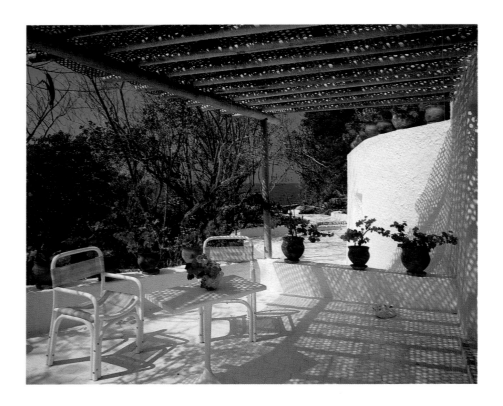

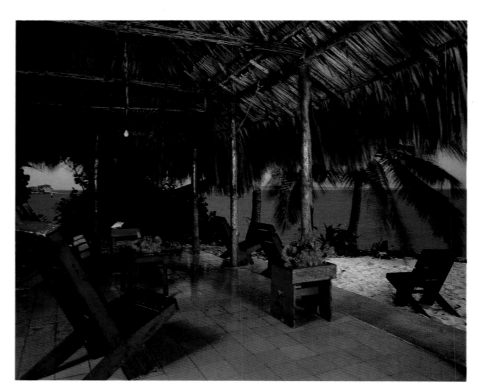

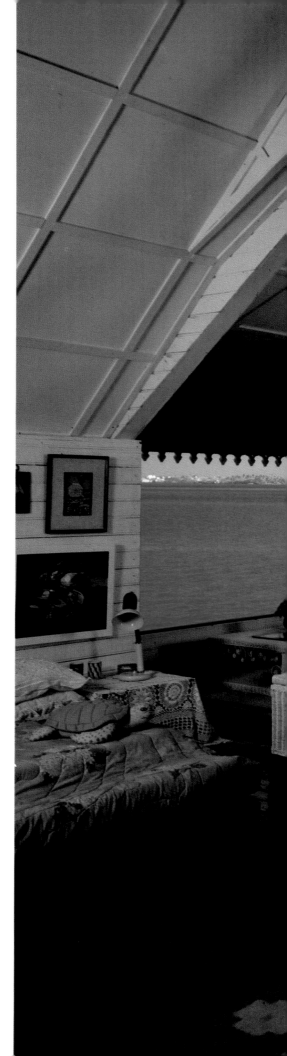

In the archipelago near Cartagena, there are native houses of
palm and lengths of timber side by side with examples of
West Indian architecture and others of Mediterranean origin.

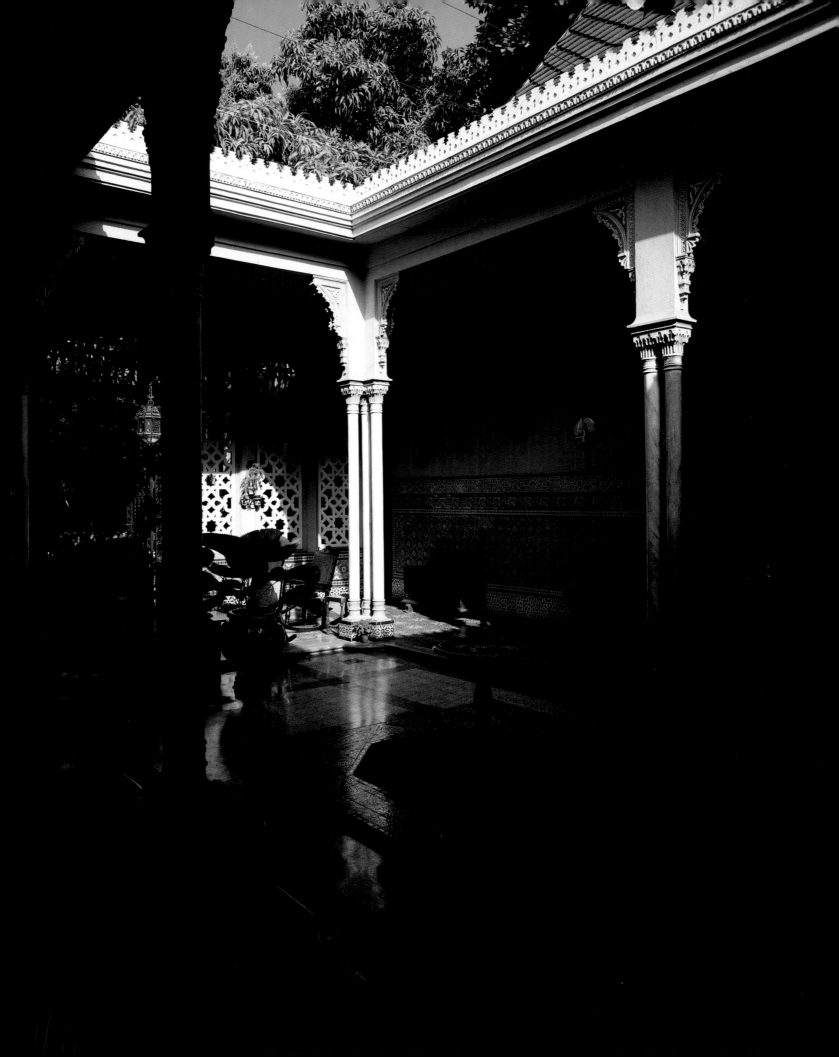

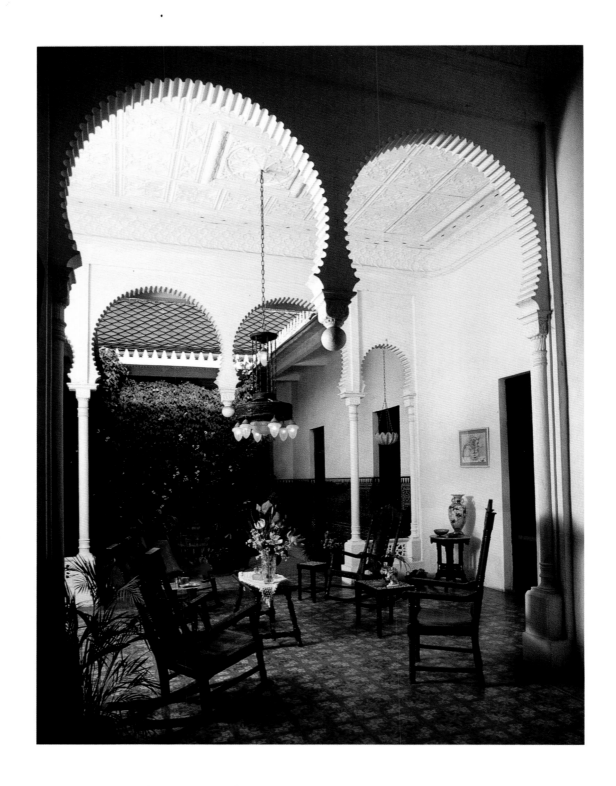

In 1880, many families decided to leave their old houses in the
walled section of Cartagena and settle in new peripheral quarters, particularly on
the island of Manga. A different architectural style identified each house. The
Mudejar architecture, an Arab-Spanish expression developed around the
fourteenth century in the south of Spain, was the inspiration for one of these
houses. The image of a Mediterranean villa was chosen for another.
This architectural eclecticism proved to be appropriate for
the hot climate of the city.

CARTAGENA, BOLÍVAR

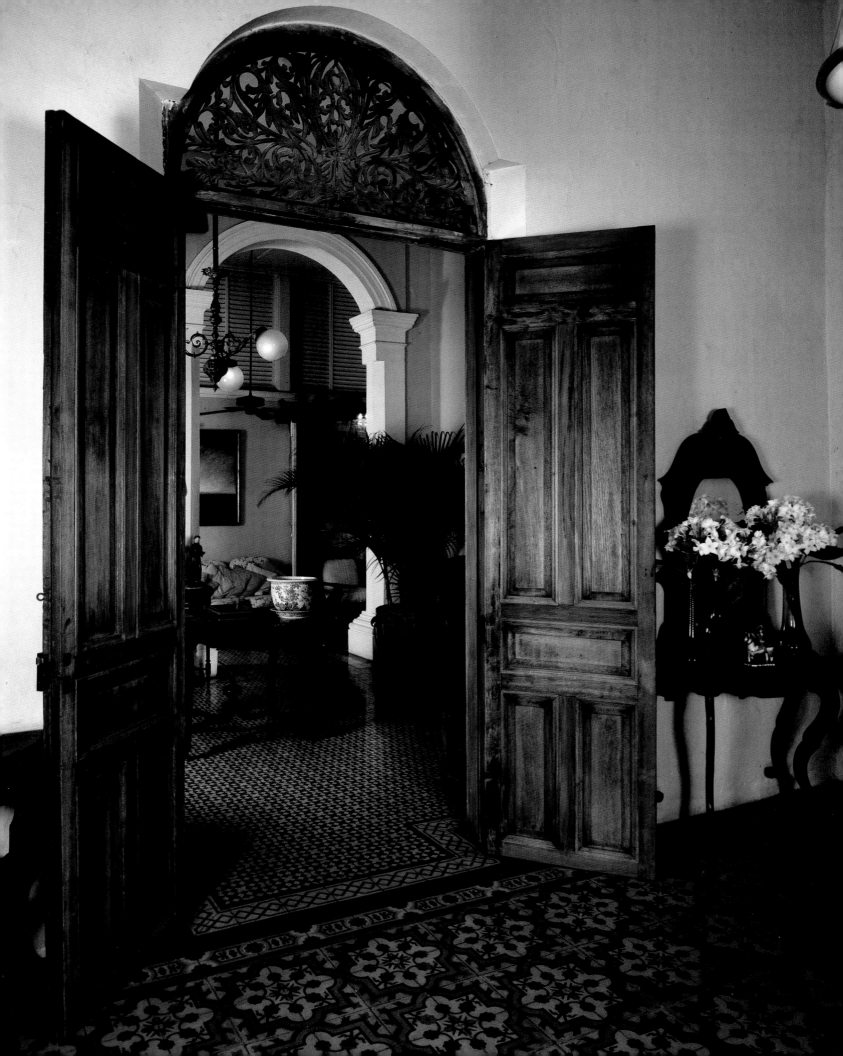

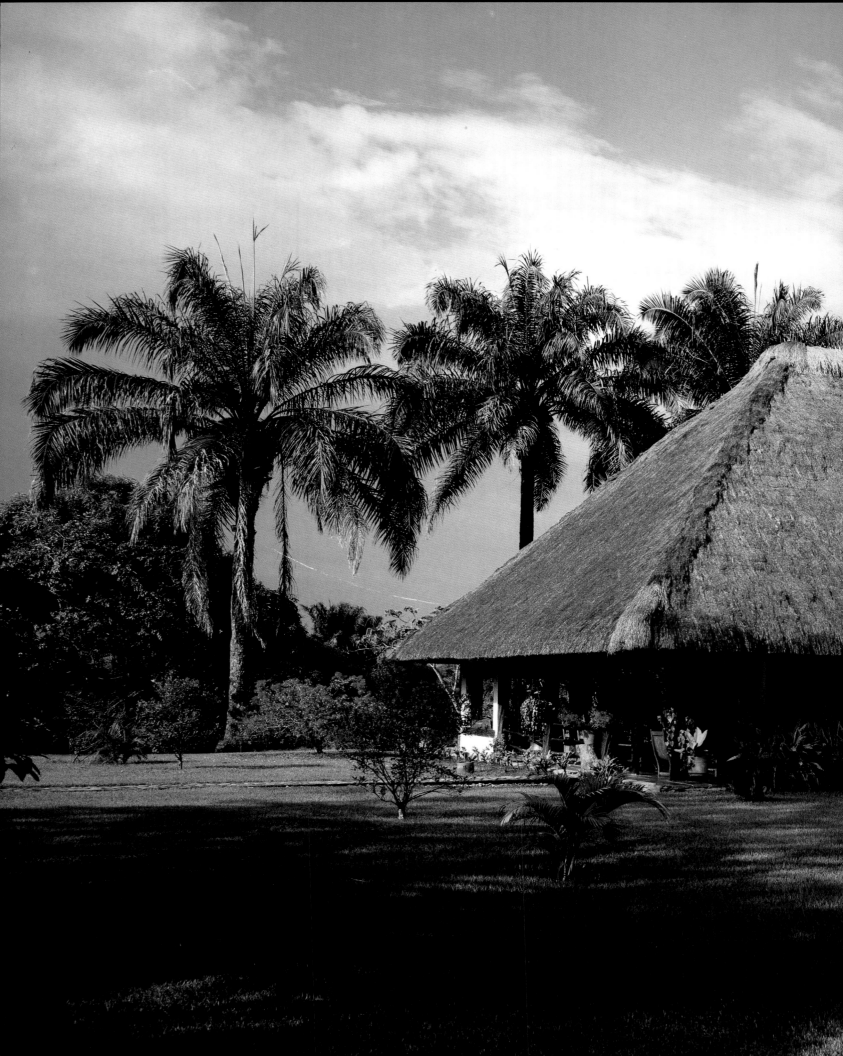

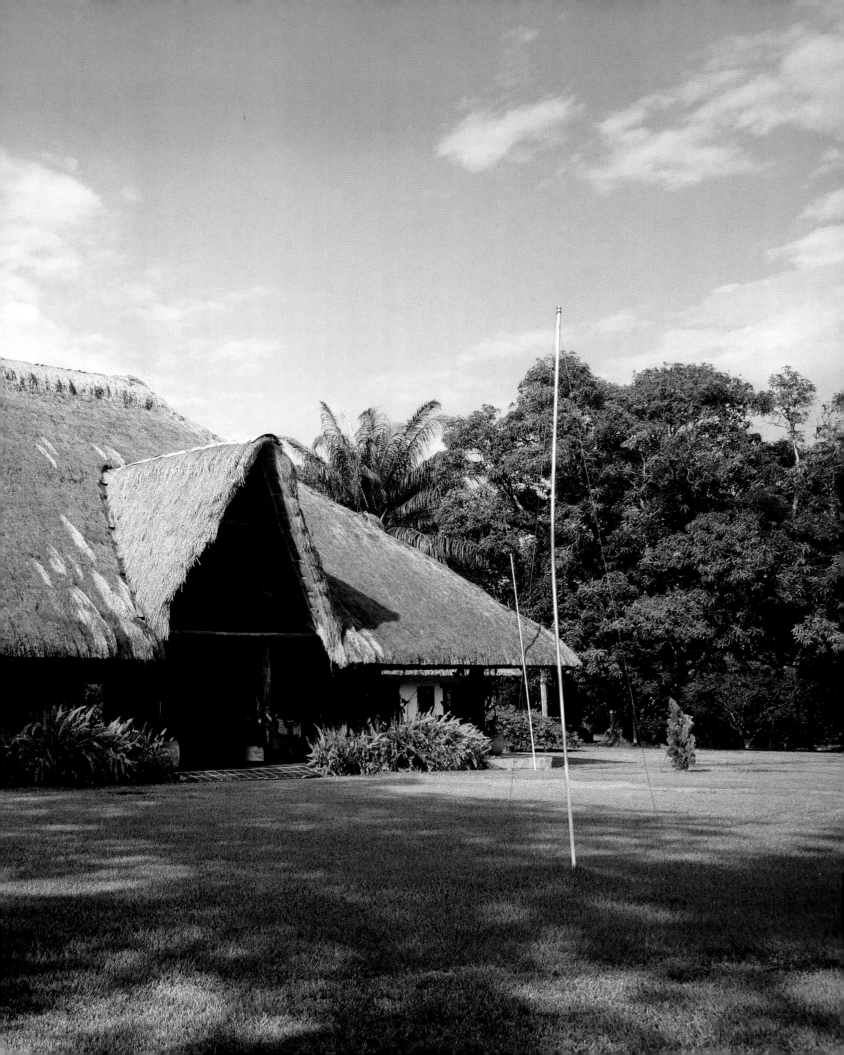

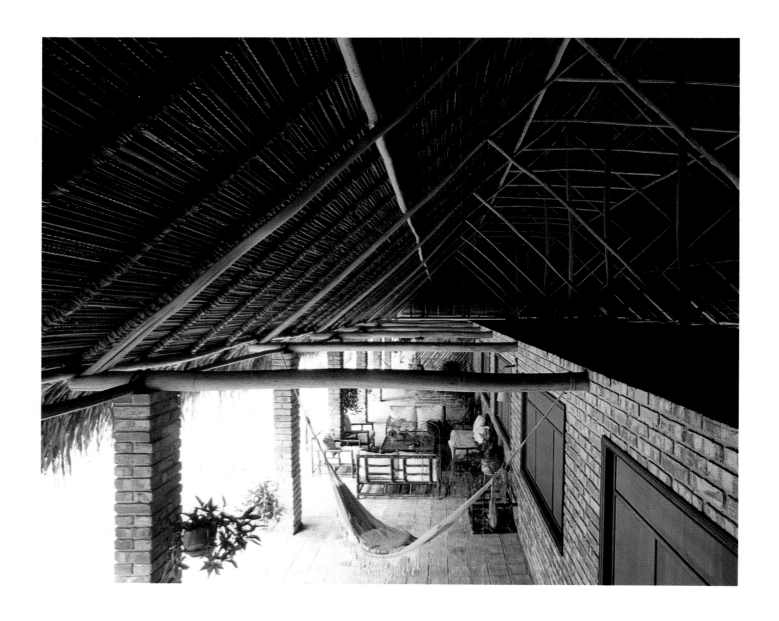

*Inspired by the tradition of the communal house of the tribes of the Orinoco and Amazon regions
of Colombia, the great house of the estates on the Eastern Plains is an interpretation of the native* maloca
*(house) as regards its fundamental elements: great size, total and exclusive utilization of local materials,
ingenious methods of ventilation, and a very close relationship to the surrounding landscape. Solid pillars form
a base for the graceful structure, and as they rise toward the pitch of the roof, become more slender until they
reach the connection between main rafters and purlins upon which lie the palm leaves.*

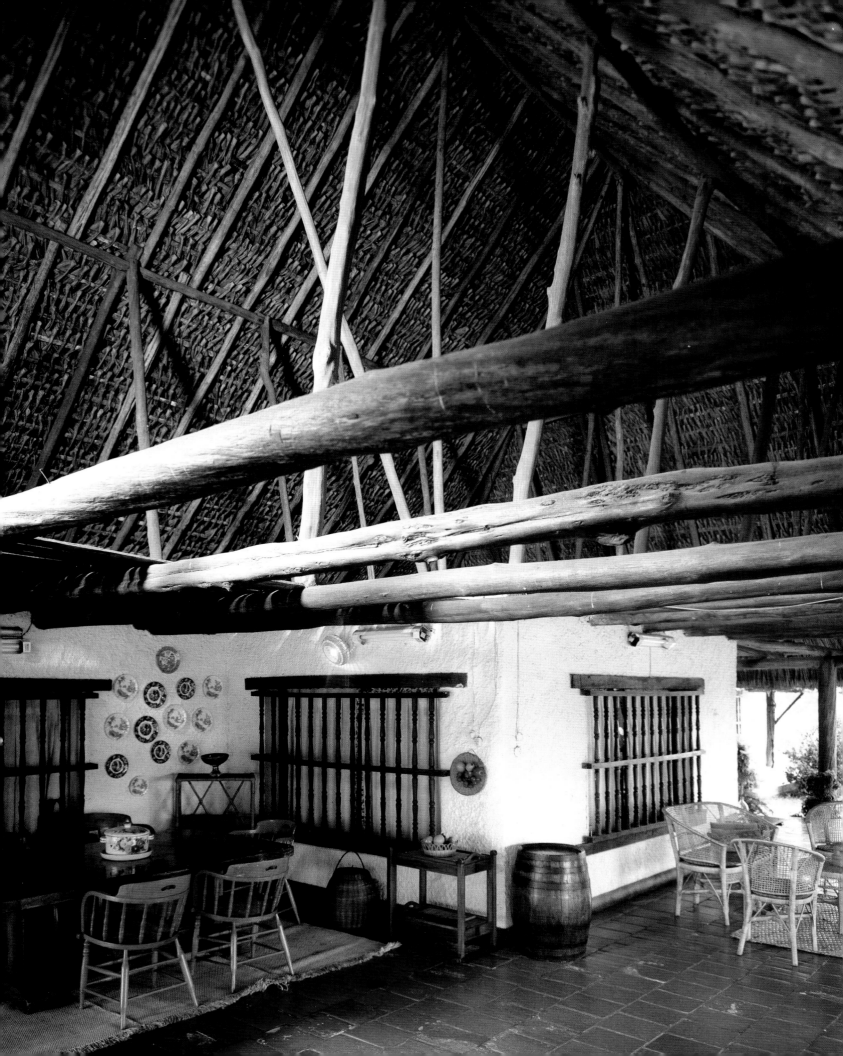

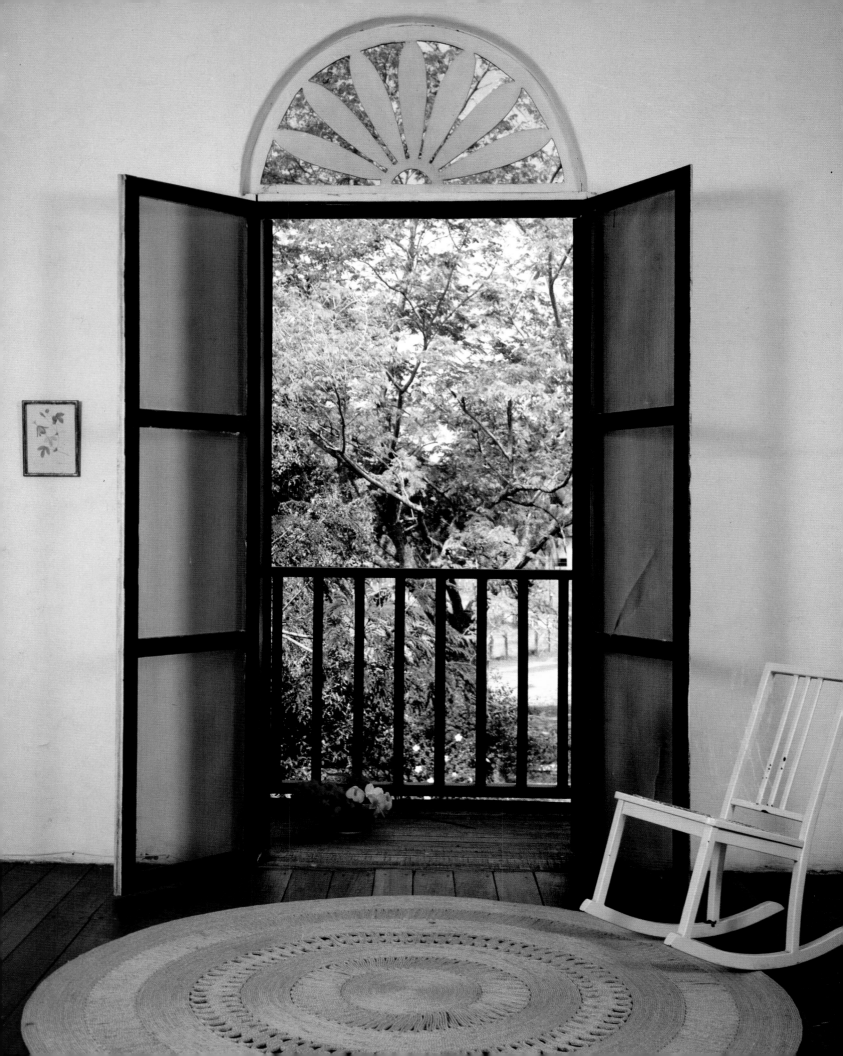

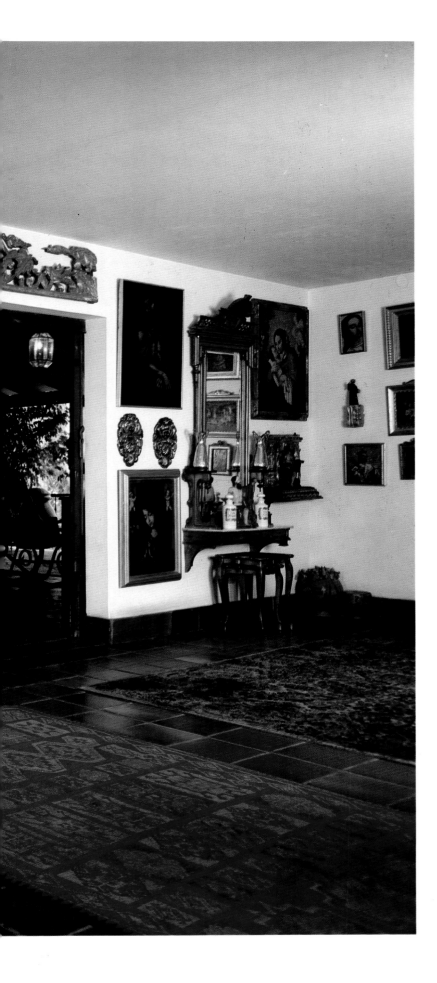

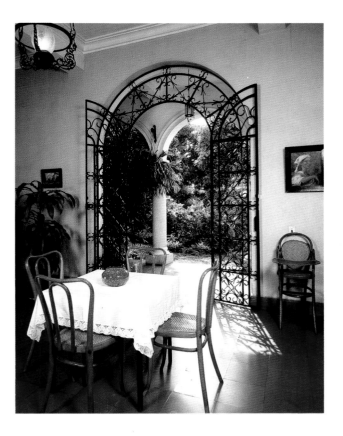

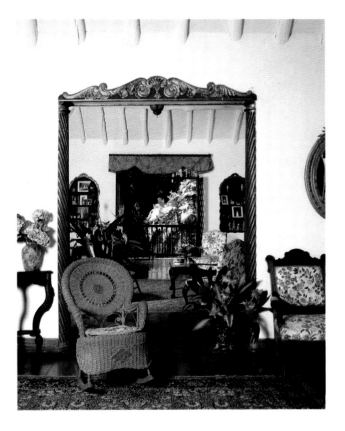

BUCARAMANGA, SANTANDER / IBAQUÉ, TOLIMA
IBAQUÉ, TOLIMA (FOLLOWING)

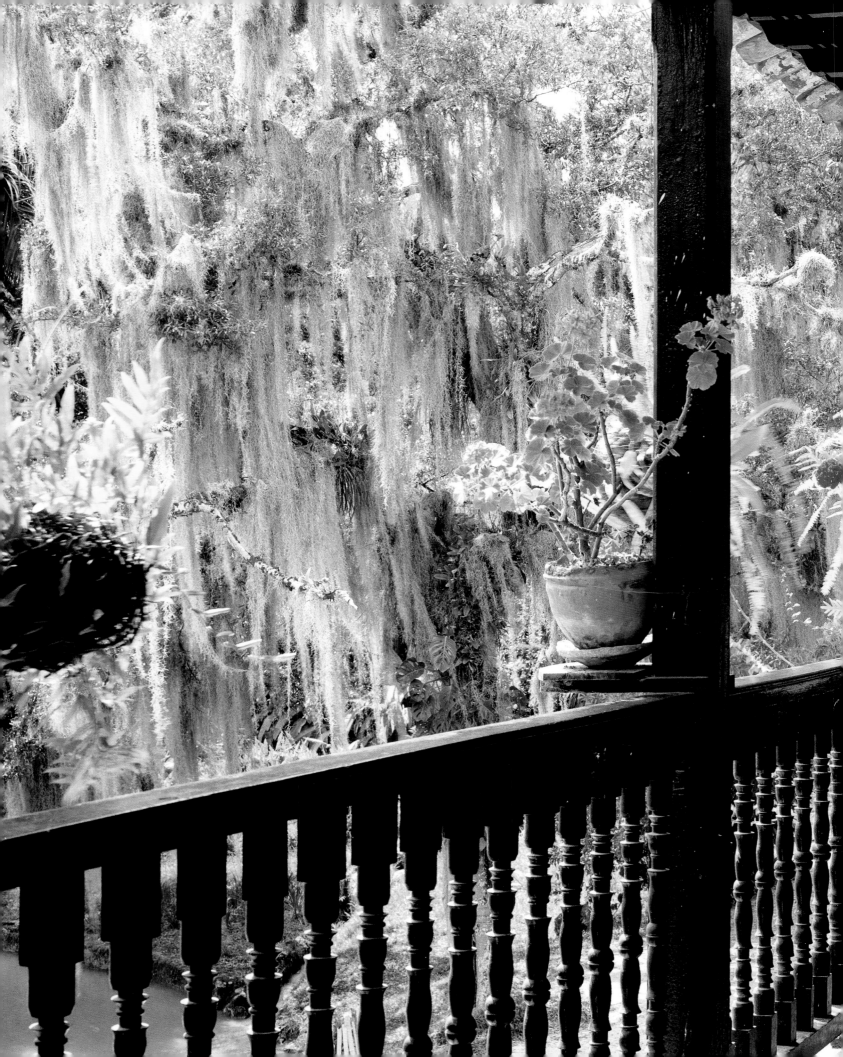

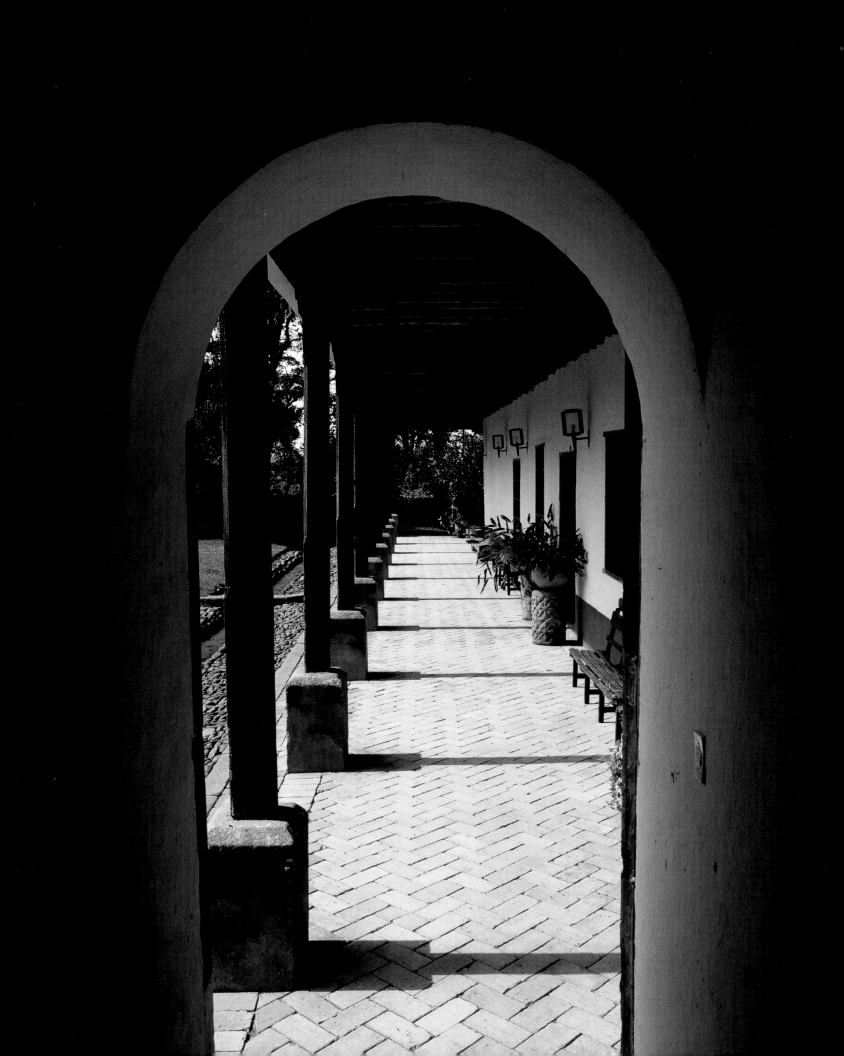

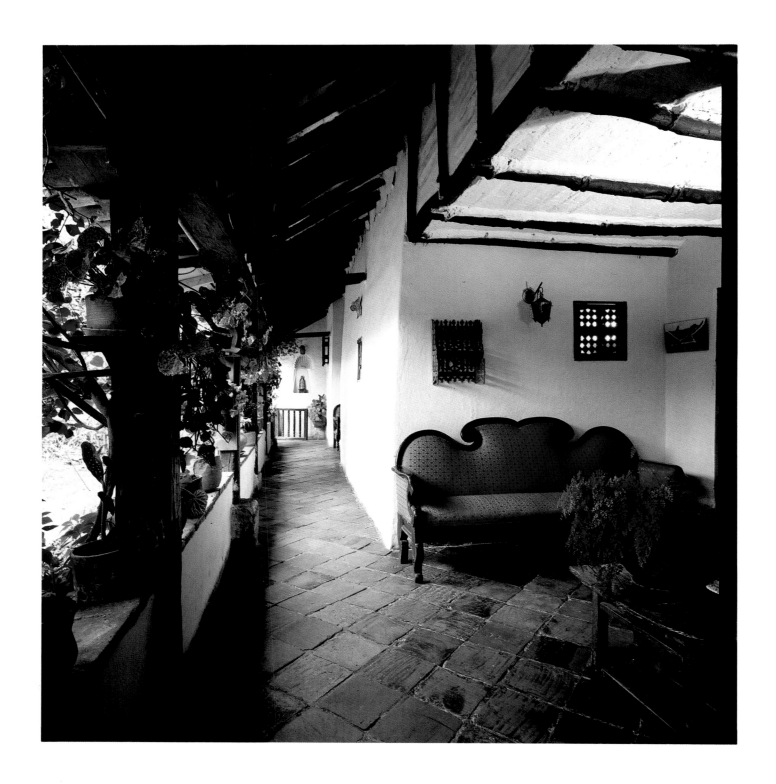

The austere nature of the materials does not in the least preclude great richness in the rooms.
Even in the passageways designed for the most humble functions, and in the servants' quarters,
the house shows great consideration in the composition of its elements and living spaces.
It contains areas of different sizes and creates particular rhythms and perspectives,
and it uses color to diversify surfaces and enliven textures.

VILLA DE LEIVA, BOYACÁ

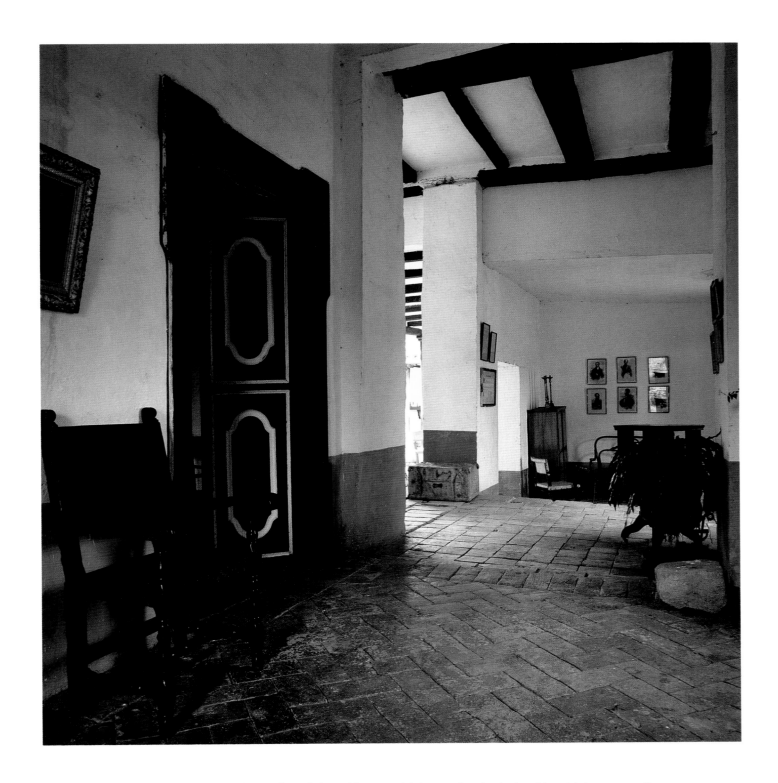

The indoor organization of the urban Colonial house, with its restricted relationship with its surroundings, continued unaltered during the period of the Republic. The entry, known as the zaguán, *continued to mark the transition and emphasized its peculiar character with the presence of the inner passageway door. Some of Popayán's centrally located houses, of Colonial origin but with subsequent Republican ornamentation, have recent versions of this inner door converted into a lattice-style wrought-iron gate surmounted by heraldic motives.*

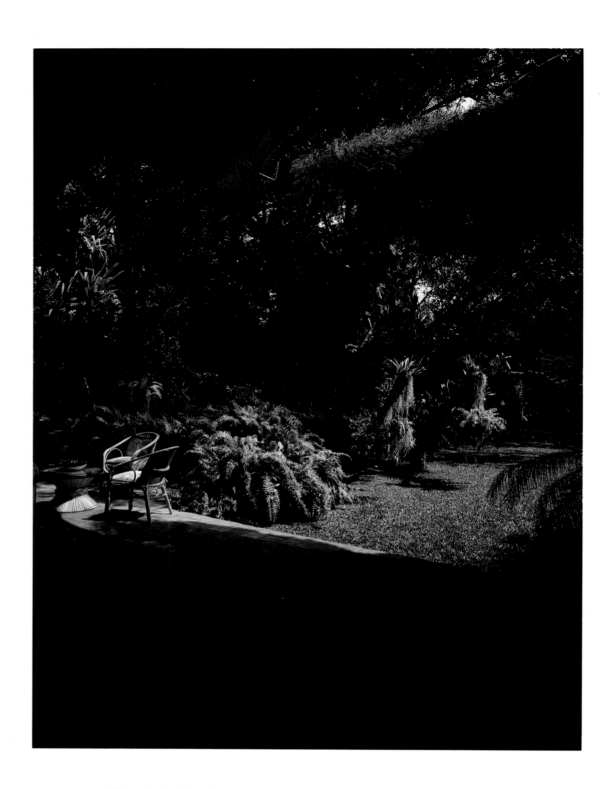

*The relationship of the rural house in Valle del Cauca with vegetation and
landscape has been constant. In the oldest estates this connection exists on
various levels in a gradual succession of spaces, and the greenery of the patio
is framed by the window as an attractive crest for the passageway.
In contemporary practice the foliage extends the indoor atmosphere,
much as a dome continues the projection of the ceiling.*

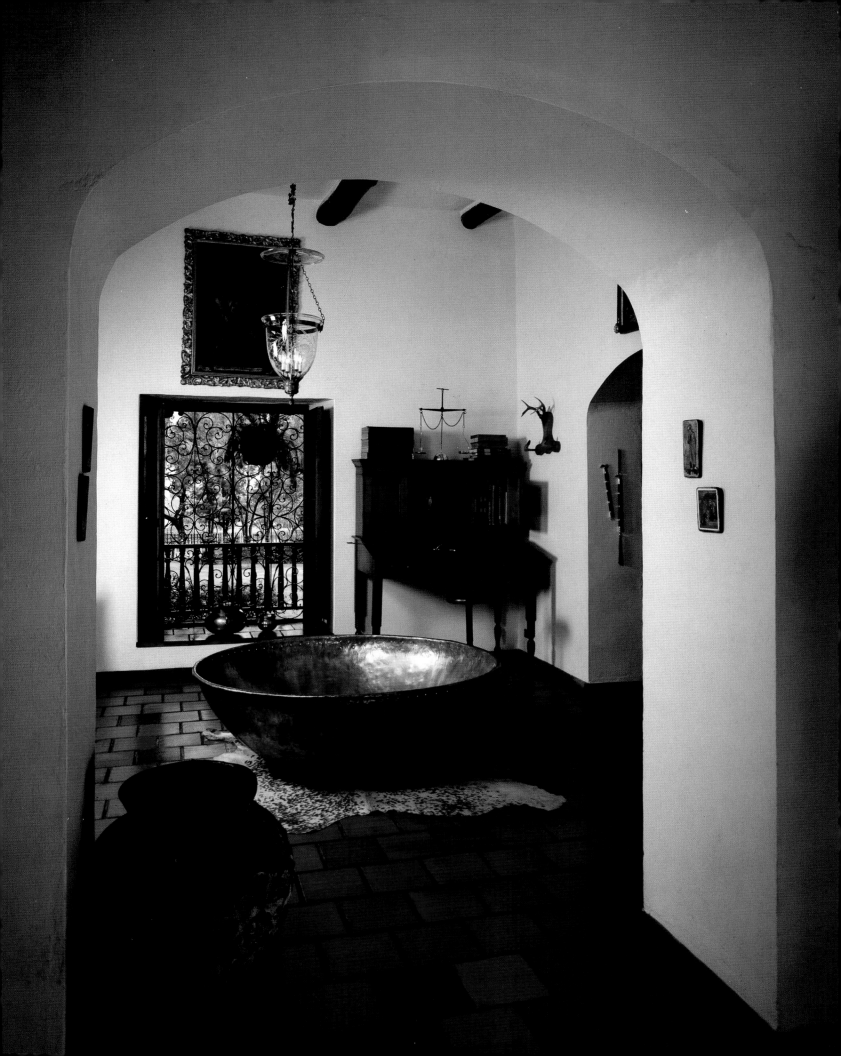

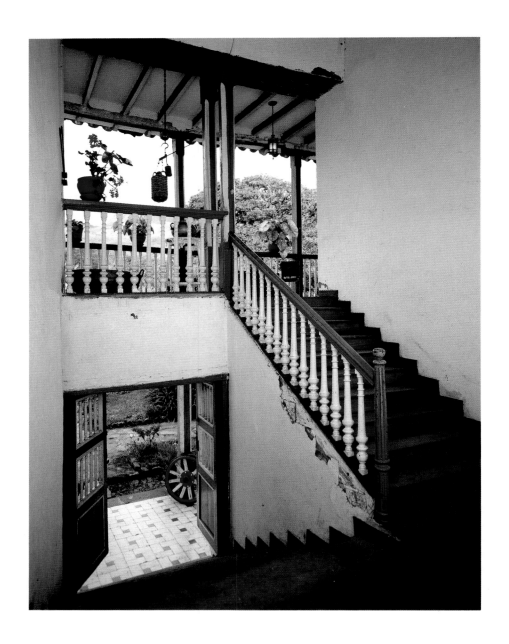

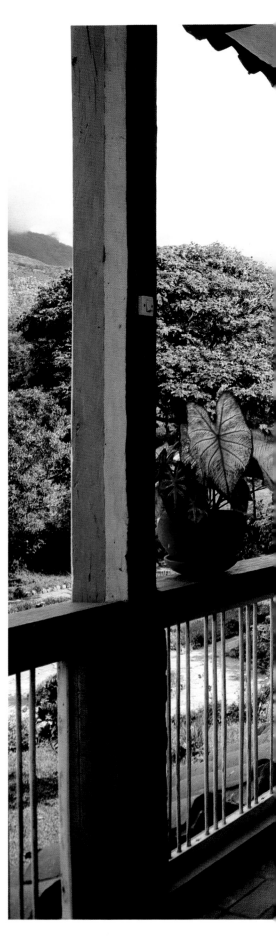

*Coffee growth was established by 1850 on the slopes along
the mountain ranges. The main coffee-growing areas are still
located in the departments of Antioquia and Caldas. In the
farmhouses it is possible to find some interesting spatial
conceptions. Rooms are visually and spatially connected to the
exterior landscape through the corridors and stairs. The corridor
is particularly important as a social space, bordered by the
rhythmic placing of columns and banisters, protected from sun
and rain by the extended eaves and colorfully punctuated
by potted plants.*

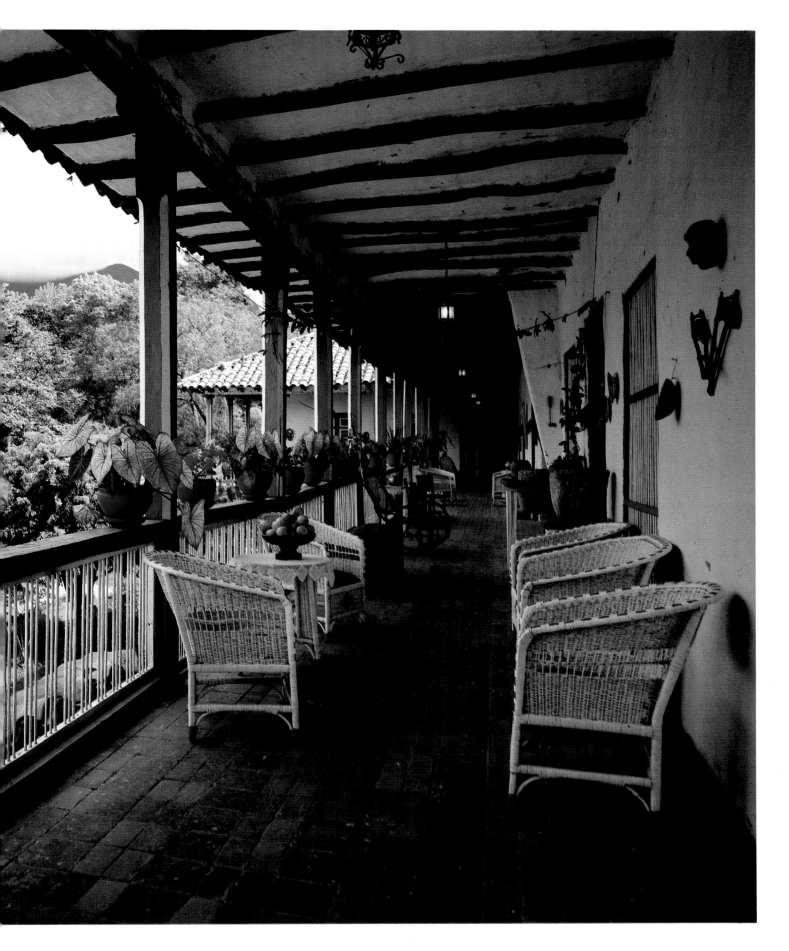

BOMBONÁ, NARIÑO

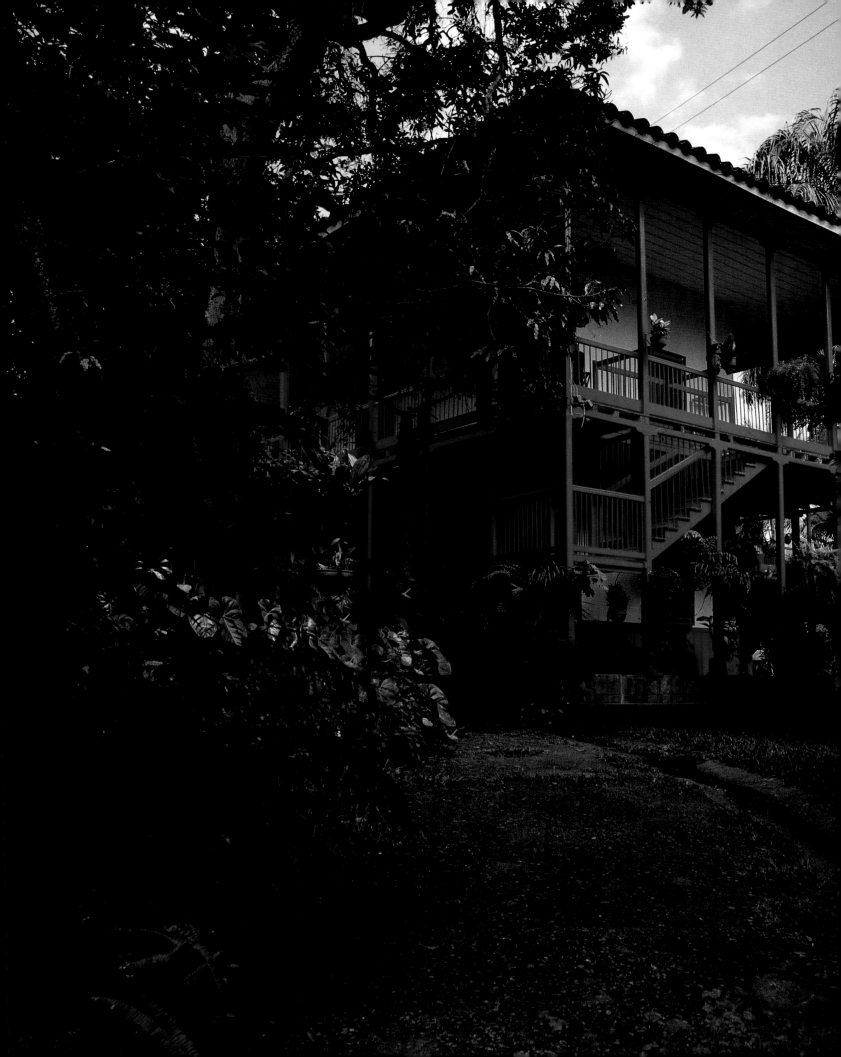

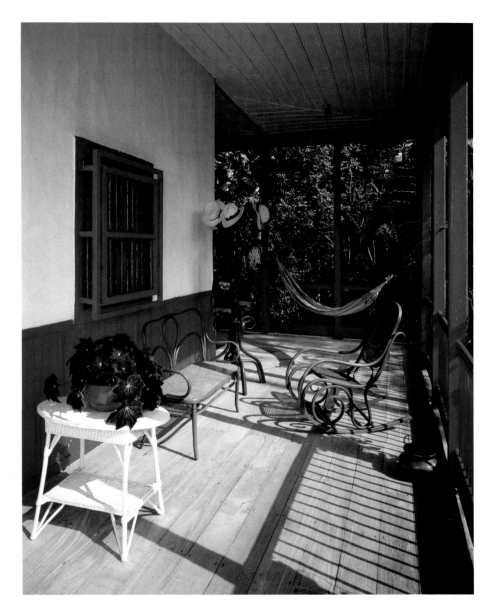

By the beginning of this century, new aesthetic codes were developed
in the architecture of the central coffee areas of Antioquia and
Caldas. These codes were based in the use of wood as building
material in structures, walls, floors, windows, doors, and furniture.
Local varieties such as guayacán and cedro (both cedars), and
chonta (a local palm tree) were initially preferred. Some of these
species provided timber for the tall columns, others gave the floor a
polished quality. The overall design of the house is masterful.

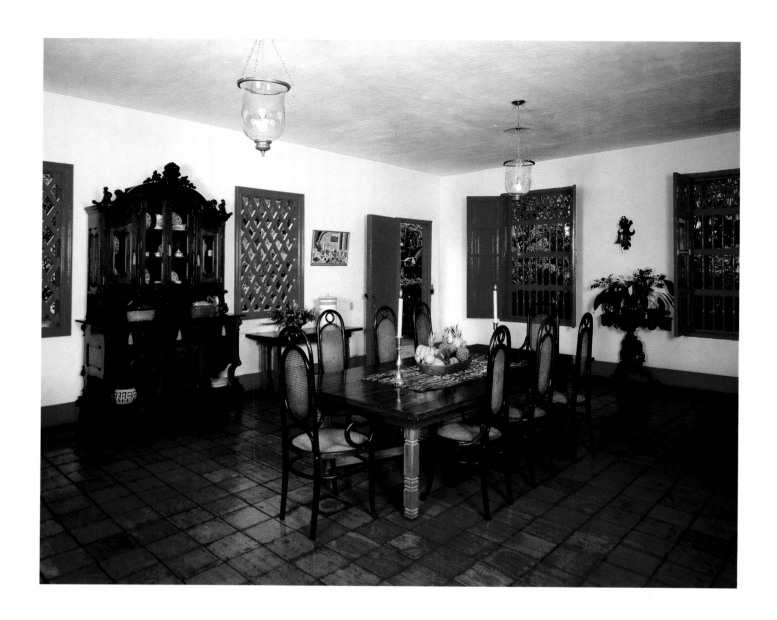

The architecture of the houses in the coffee regions of Antioquia and Caldas is part of a larger cultural process known as the Colonización Antioqueña, *or* Antioquian Colonization, *which occurred during the nineteenth century in the central and western areas of the country. New types of houses based on preceding Spanish colonial patterns were built in both rural and urban areas. Great technical skill, taste, and elegance are found in the details that reveal the new influences coming from contemporary European decorative forms. Rooms are well proportioned and finely built in wood. The use of color enlivens the spirit of a rural dining room. White emphasizes the elegance of an urban residence.*

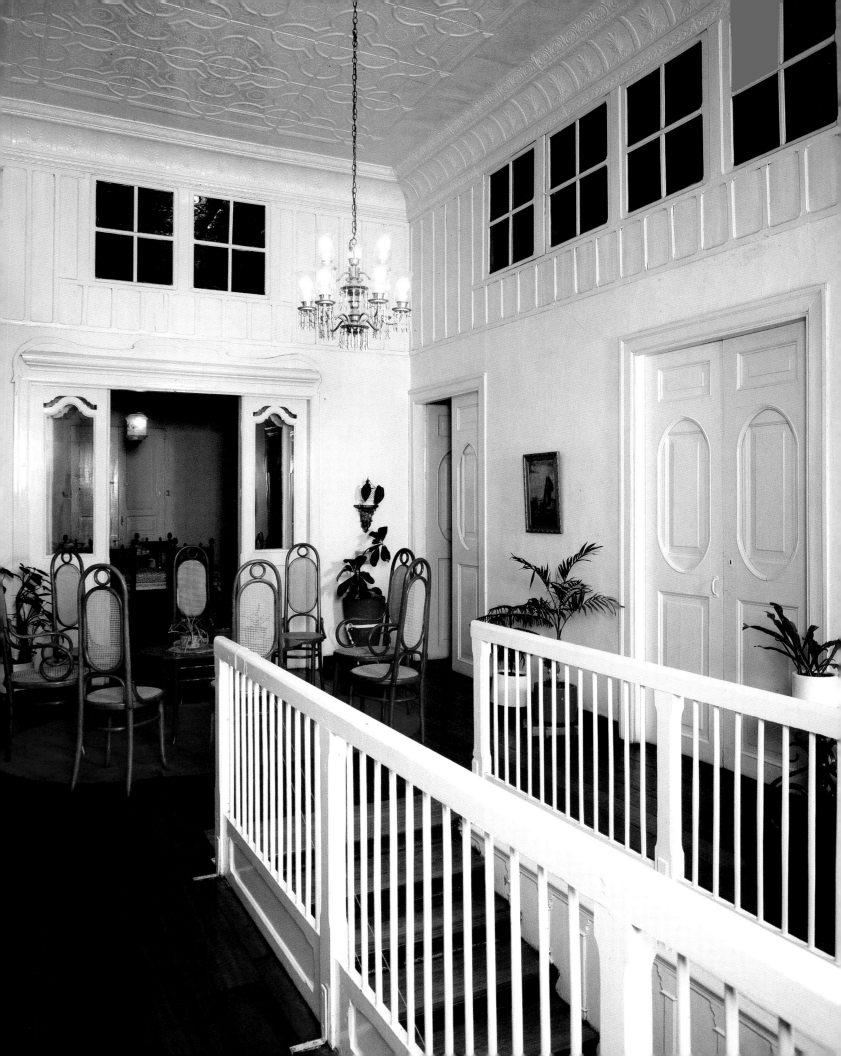

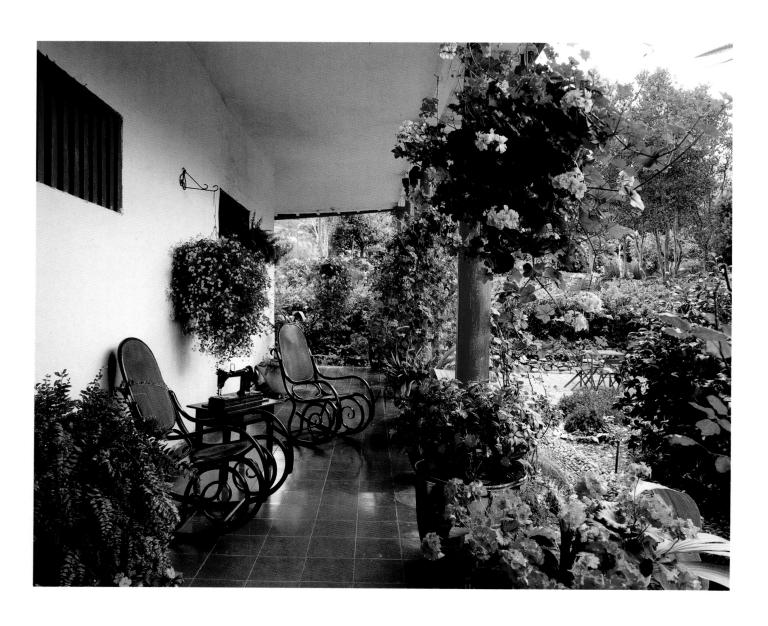

The lasting success of the Colonización Antioqueña *was possible on account of the social, human, cultural, and economic factors that combined to fulfill it. The men from Antioquia, who, bent on expansion, set out on that long trek in search of better soil, belonged to doughty patriarchal families. Tenacious and well prepared for adventure, they yearned to dominate nature. And, with the help of their families, they began to lay the foundations of solid patrimony. The economic structure and the social organization of the colony led to the definition of a regional identity, evident in the way the settlers tended the land and built their houses.*

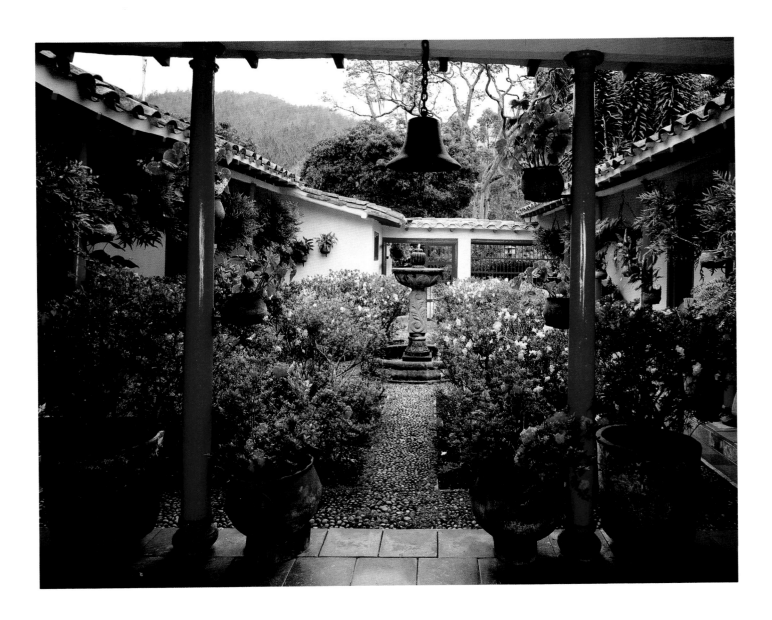

The rise of the economy of coffee increased prosperity, enhanced commercial activities, and allowed many families to pay more attention to the embellishment of their houses. Farmhouses were places where different activities were carried out under the specific guide of the woman of the house. The feminine influence is present in the choice of furniture, the disposition and care of plants, and the overall decorative sense. Apart from the practical furnishing, the beauty of the house and its surroundings was established as a cultural value, a source of pride for the owners and of enjoyment for the visitors.

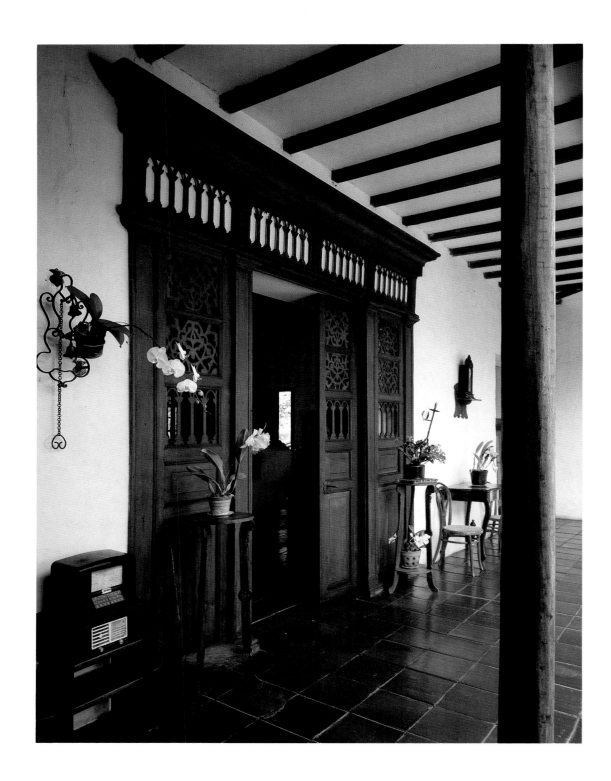

Following regional traditions, the second floor of the urban house of the Caldas region was the piano nobile, *the most important part of the house. The main rooms of the upper story surround the central courtyard. Corridors are protected from the sun and rain by the wide eaves, beveled at the corners. Whitewashed walls serve as a background for the slender columns and banisters and help to improve the contrast between the elaborate carpentry of the door frames and the wooden lace of the dining room folding screen.*

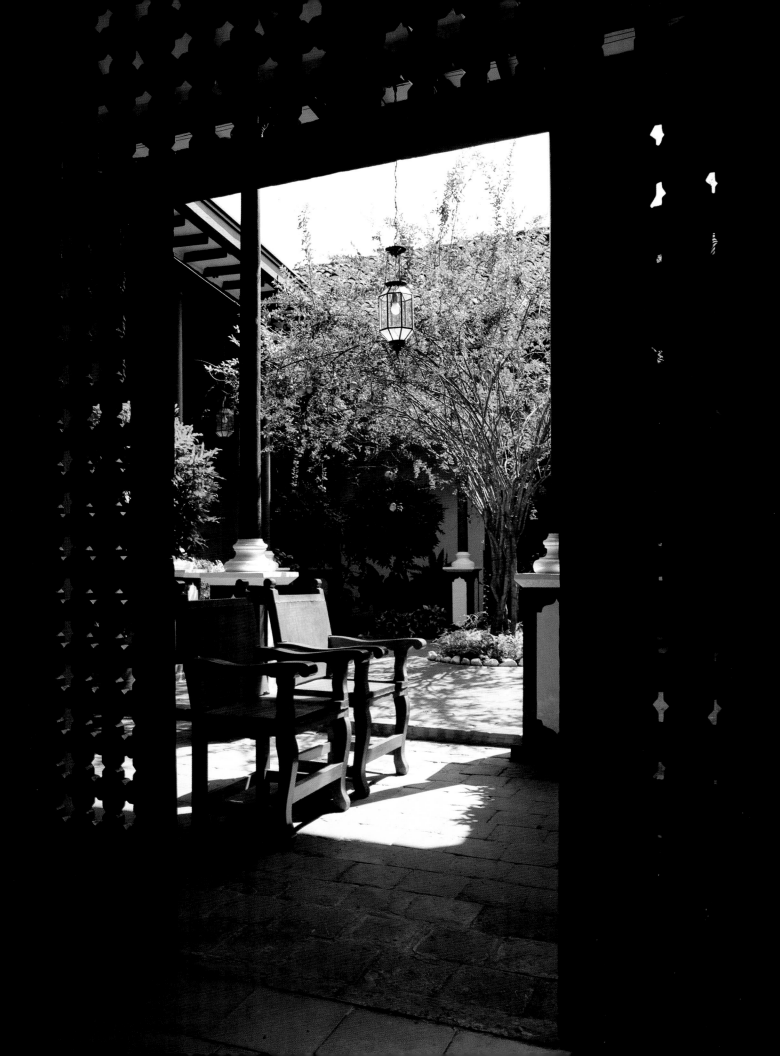

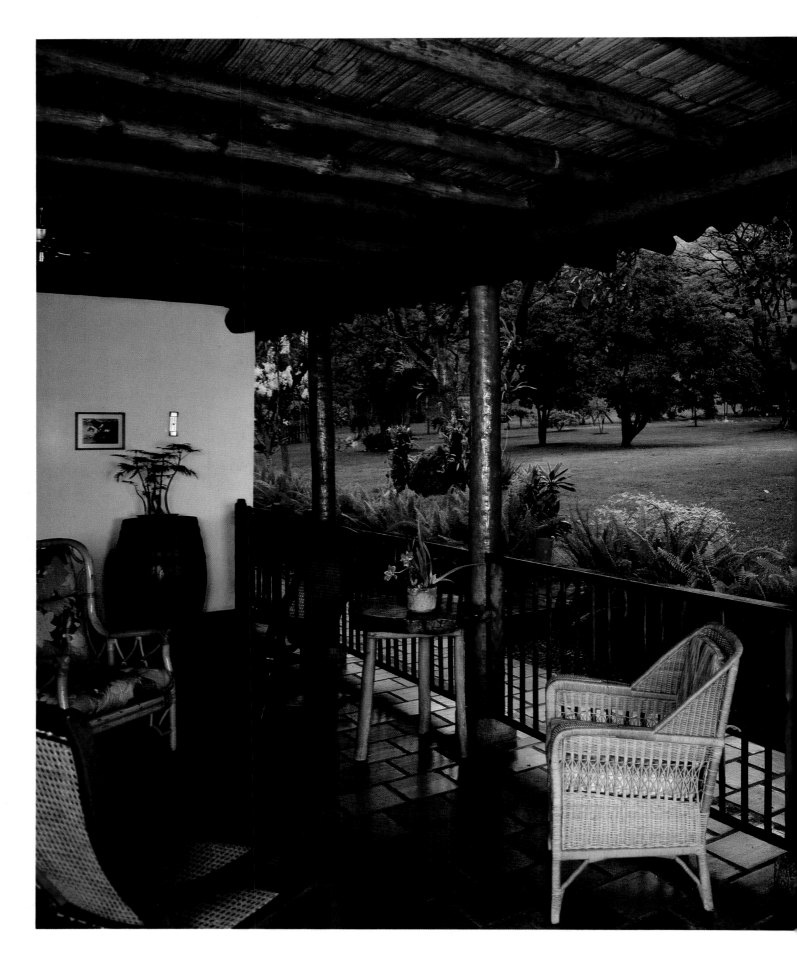

YUMBO, VALLE DEL CAUCA

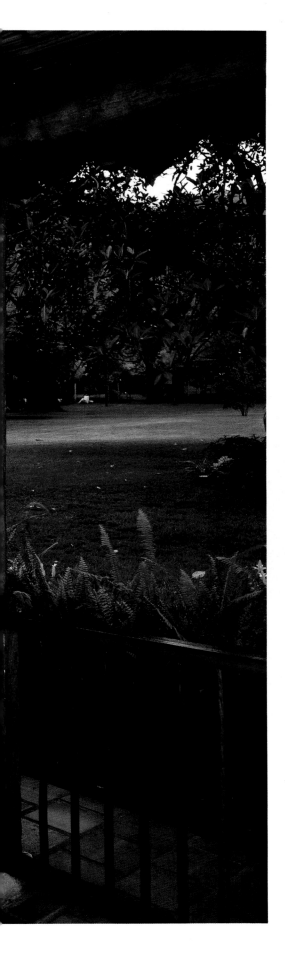

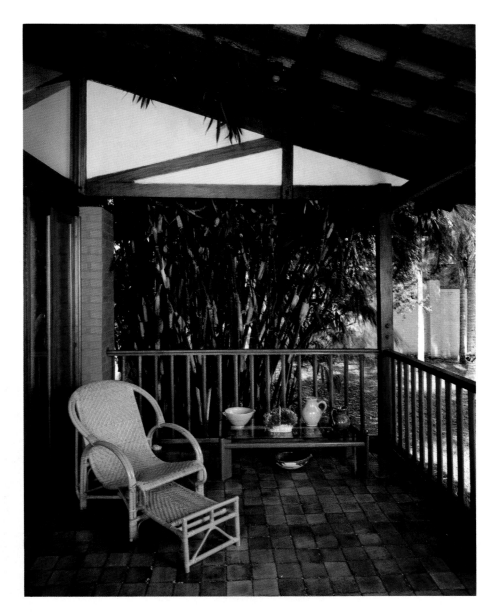

Building techniques developed as part of the colonization of
Antioquia and Caldas are now rooted as cultural expressions.
The environmental and aesthetic qualities of these techniques take
into account the identity of the building materials and their fitness
to the climatic conditions, particularly to the warm humid weather
and the daily seasonal changes in the temperature. Contemporary
approaches to the shaping of the domestic environment explore new
practical and aesthetic ways of using bamboo, wood, and natural
fibers—materials widely used in popular architecture.

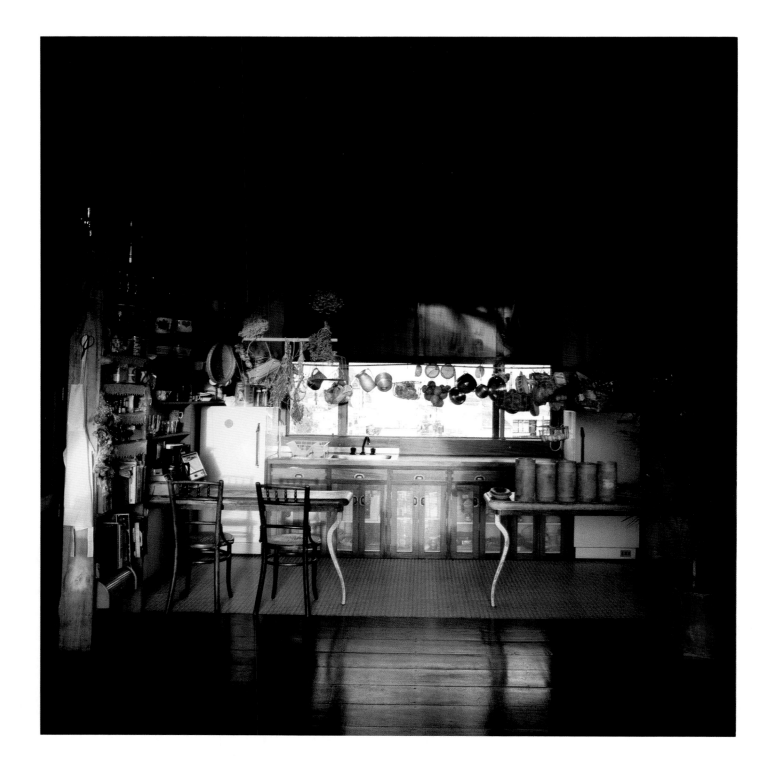

As an affirmation of identity and an extension of the popular traditions, the present-day urban house reproduces the colorful rustic atmosphere of the traditional kitchen by inserting characteristic accessories, many of them divorced from their original function but very effective now as decoration. This is likewise the sense of the display not only of artisan-fashioned pots and other utensils such as gourds and earthenware, but also of tropical fruit and labeled jars of spices and seasonings.

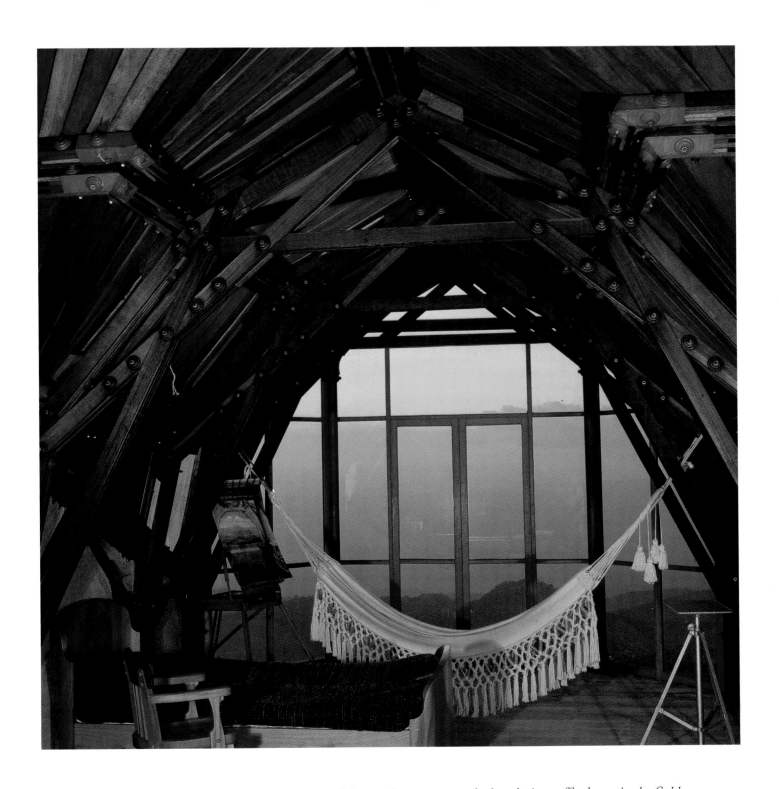

The architecture of this house is reminiscent of the wood structures used when drying coffee beans in the Caldas region. The experimental approach to the use of wooden trusses has a dual aim: to solve a technical challenge and to achieve an aesthetic rewriting of deeply rooted cultural images.

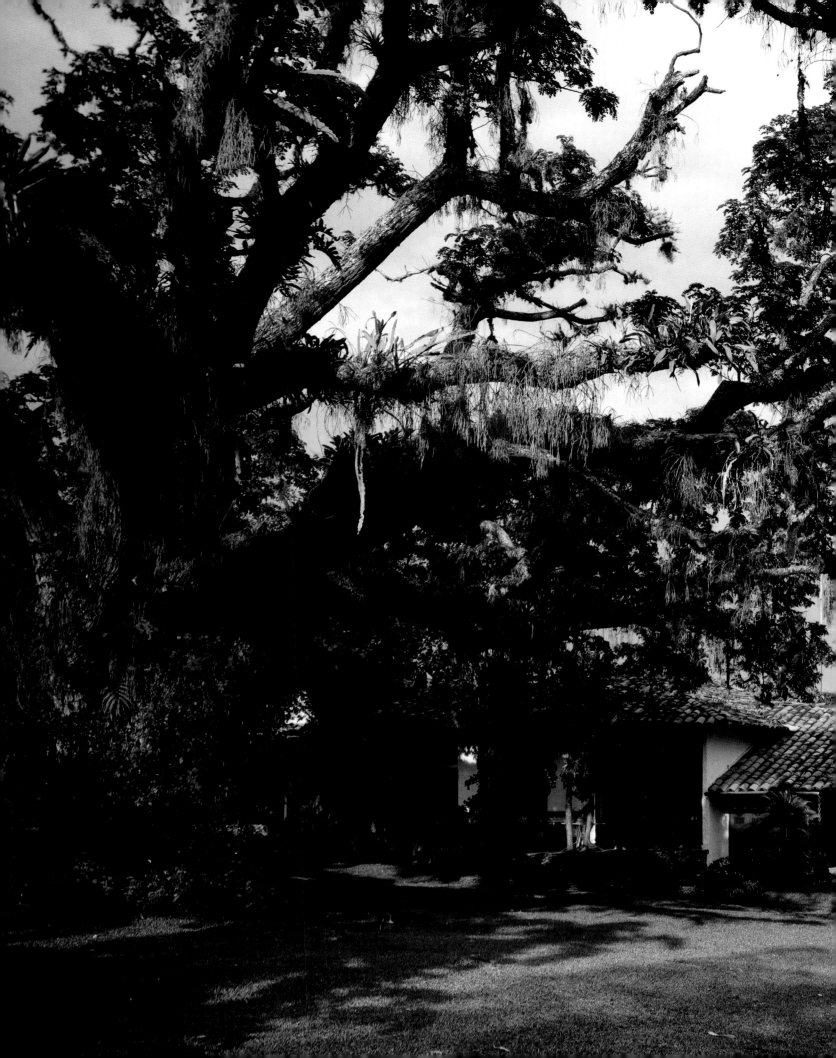

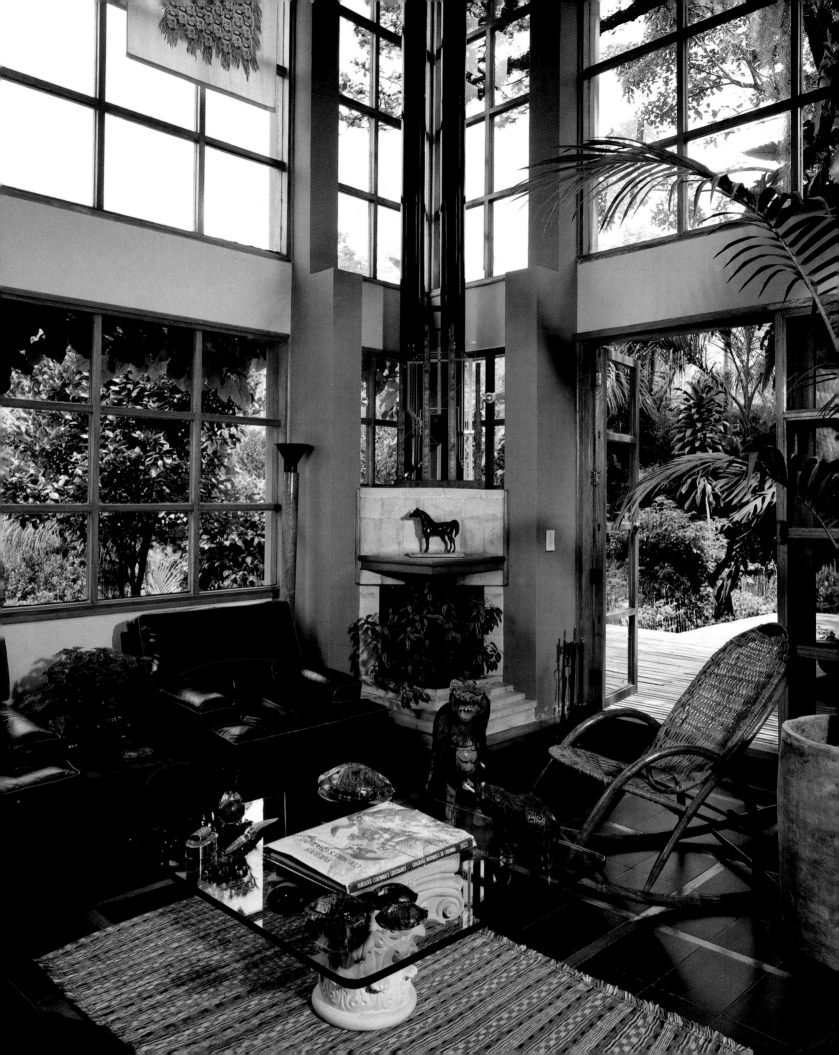

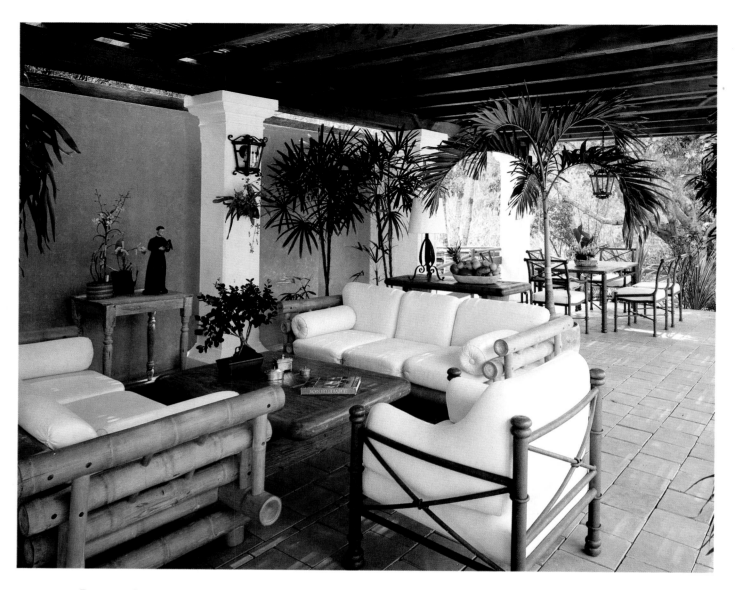

Regional building traditions have found diverse expression in contemporary tropical architecture and have also extended to furniture design. More and more often, furniture integrates architectural elements or the atmosphere, with its domestic contents based on native materials, which, like bamboo, have diverse applications in the field of industrial design as well as the applied arts. The essential advantages of bamboo, namely, great strength, a handsome appearance, natural finish, and ease of use, give design and manufacturing of bamboo furniture a natural approach to a contemporary process.

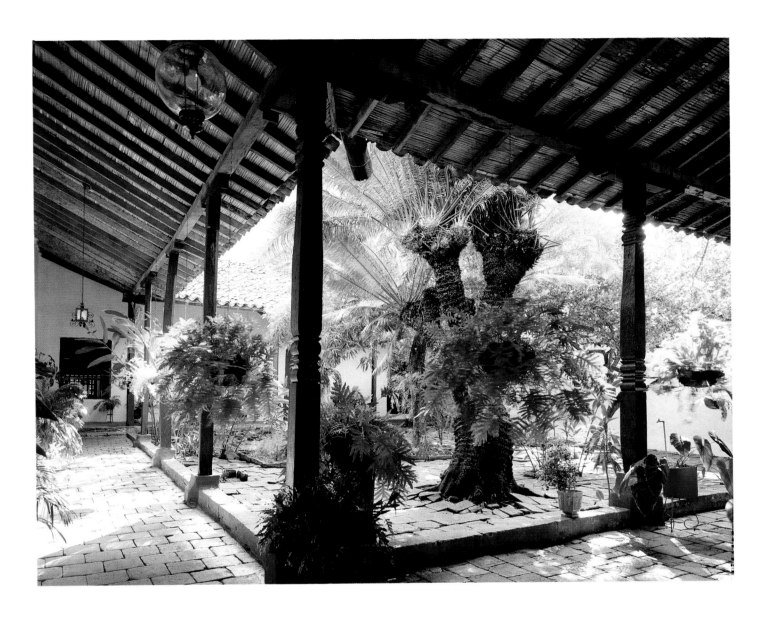

The natural beauty of bamboo and wood—native materials used constantly when building in the tropics—encouraged an architectural expression that continues to enrich contemporary living spaces. In the hot northern districts of Antioquia, that building tradition gained particular importance in the development of Santa Fe de Antioquia, a prosperous colonial urban center in the mining region during the seventeenth and eighteenth centuries. Despite the decline of gold mining, the city maintained the quality and beauty of its domestic architecture. Even today one appreciates the way in which the roofing of the corridors in many houses allows close observation of their components, which are quite in keeping with the equally regional baked-clay pavement that extends to the patio.

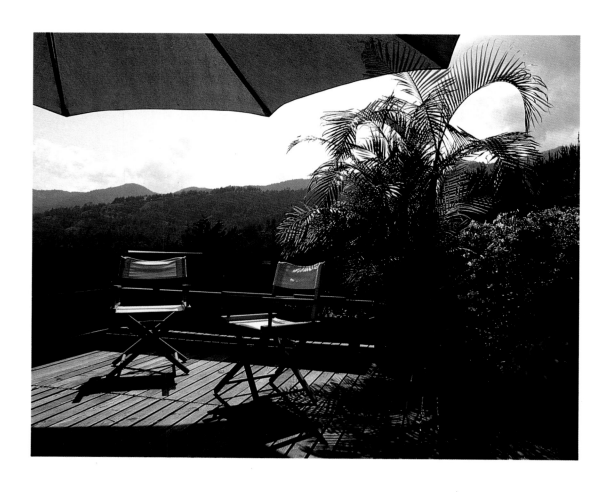

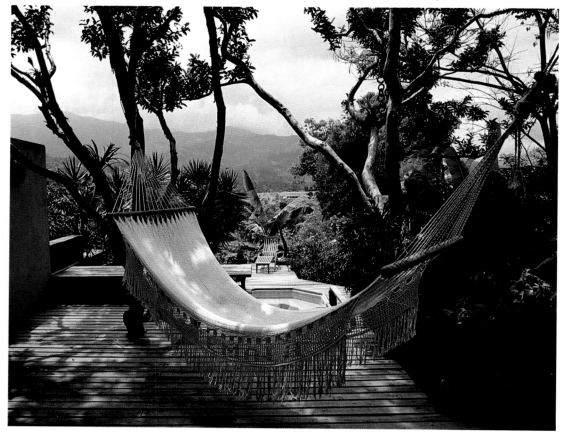

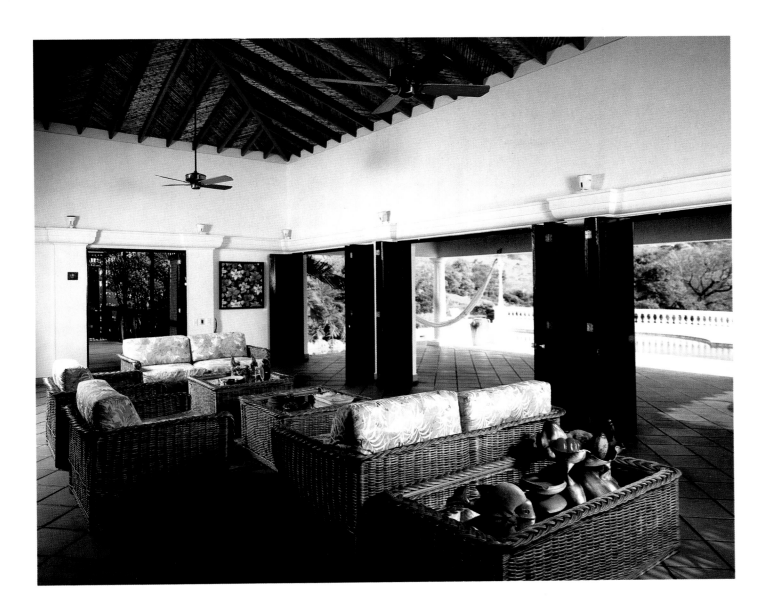

The demographic pressure exerted by Medellín on the valley in which it is situated has encouraged the
development in the surrounding regions of a suburban house that may serve either as a country house
for rest and recreation or as a permanent residence. Having appeared first in the neighboring hillside towns,
this type of house extended to the Rio Negro plateau and onto the outskirts of the towns along the Aburrá
Valley toward the north and the west, on the road that leads to the canyon of the River Cauca.
Some people kept old farmhouses and added the up-to-date features of a city residence,
while others preferred a product of contemporary architecture with a swimming pool dominating
the landscape. Here, too, are native materials, with wild cane for the ceilings and macana,
or mangrove, wood for the floors of the small terraces.

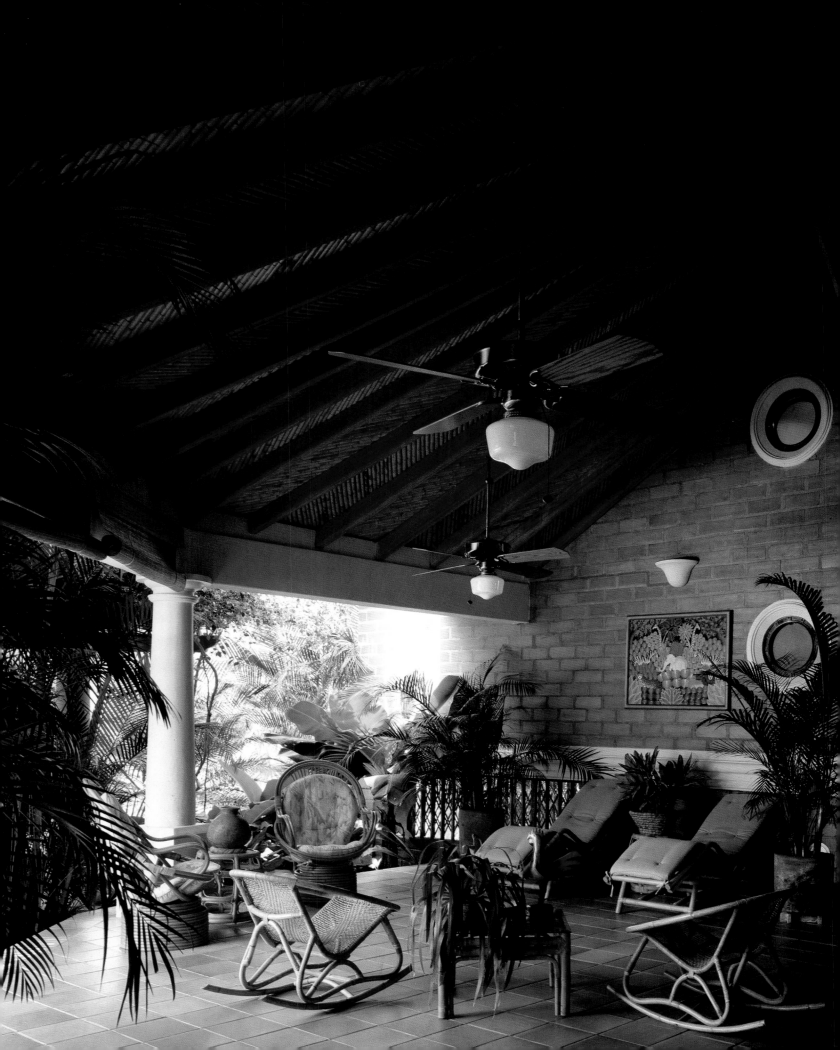

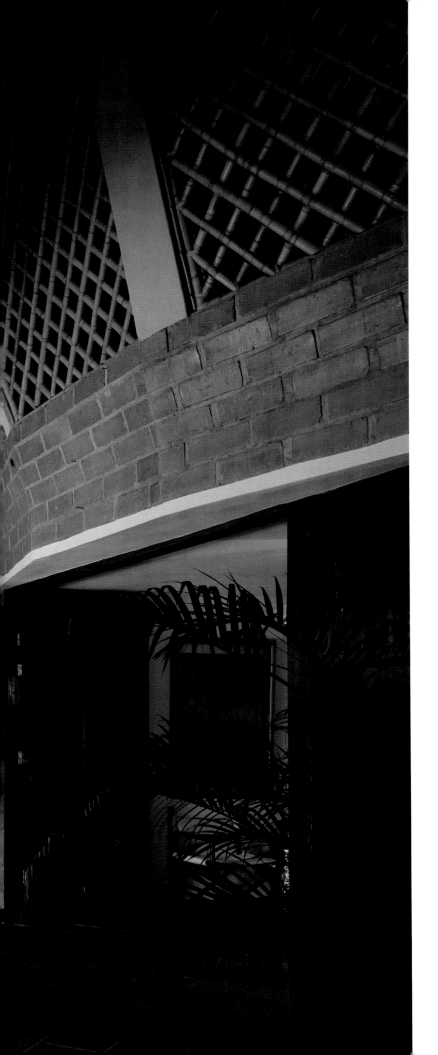

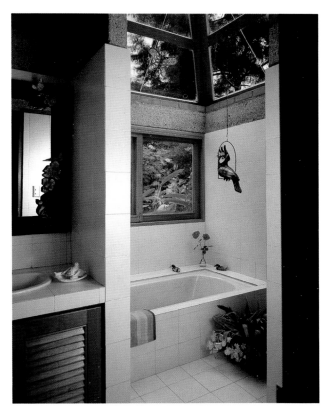

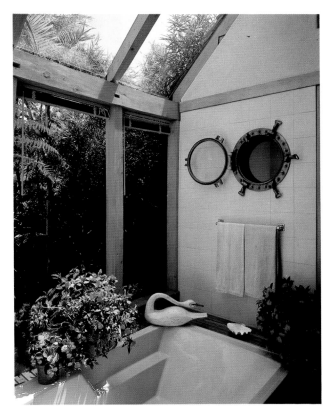

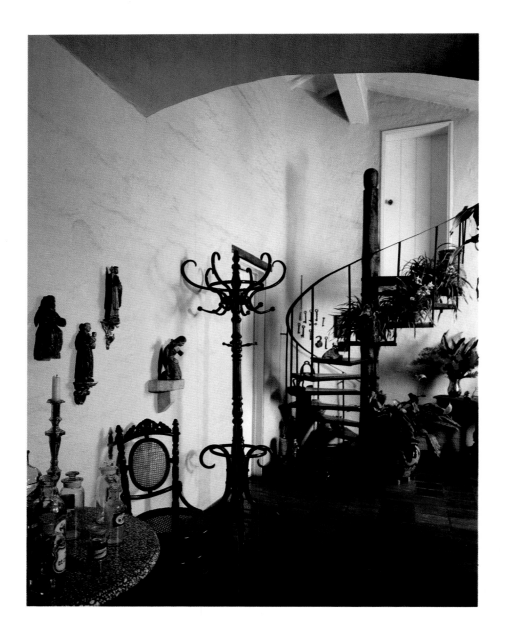

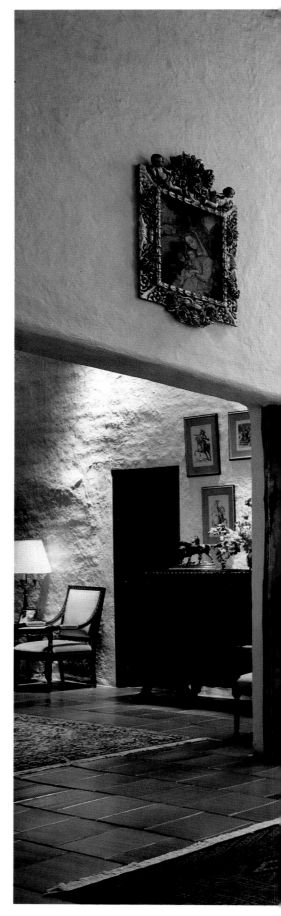

*White on surfaces of strong texture and the contrasting tones
of wood and baked clay are often associated, in the contemporary
interior design, with the notion of austerity assigned to historical
architecture. This technique, combined with natural and artificial
lighting, is very effective in giving character to living areas and
prominence to the position of the furniture, objets d'art, and other
objects that acquire significance in family life and reflect traditions.*

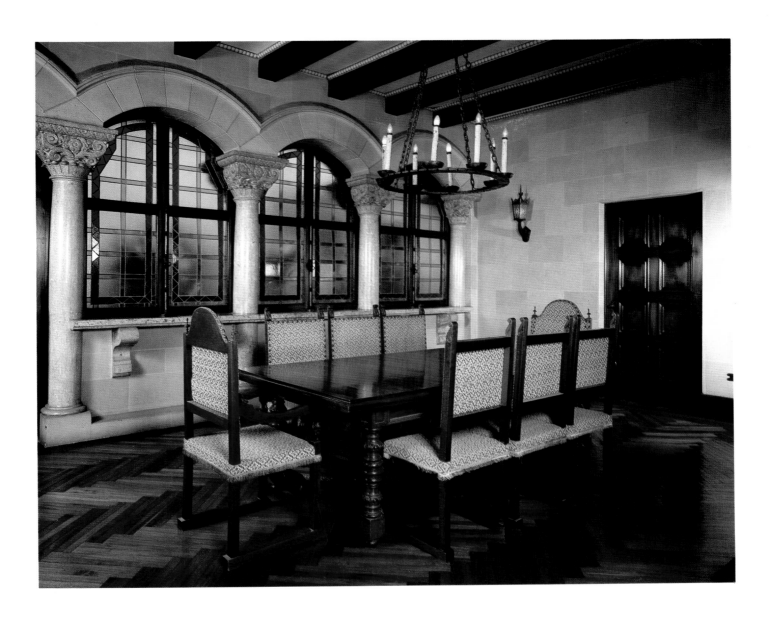

El Prado, one of the first outlying districts of Medellín, was intended and planned to be exclusively residential. It came into being in the late 1930s, a prosperous period for Antioquia, due to a boom in the cultivation and exportation of coffee, active commercial relations with Europe, and the vigorous incipience of industry, all of which betokened an advance toward modernity and refinement in daily living. During the layout of the steep streets and avenues, the first consideration was the planting of generously fronded and brightly flowered trees in parkways, sidepaths, and front gardens. El Prado is a veritable catalogue of eclectic expressions, rich both in technical resources and in hints of fantasy. Each city block is a review of trends and fashions, displaying rivalry in the imaginative facades. There is an abundance of marble, stone, reconstructed granite, wooden veneer and molding, parquet floors, and stained-glass windows of modernist inspiration.

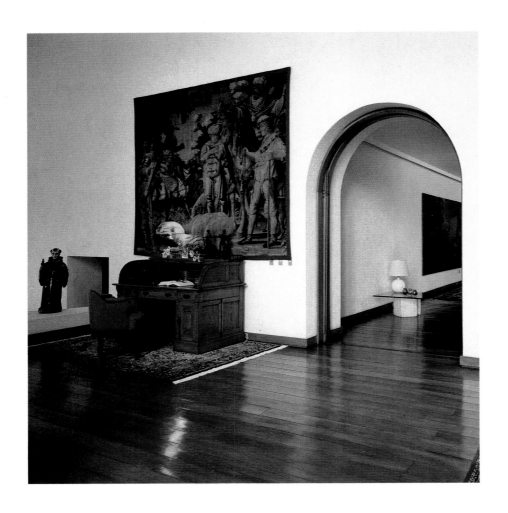

It is the art, the refinement, and the vigorous selection of furniture
and its complements that quite often determine the subordination
of space to contents. Architecture thus falls back on an exercise of
neutrality, in which the volume created, its dimensions, the materials,
and the chromatic severity of the surfaces subserve the luster
and quiet contemplation of the objects.

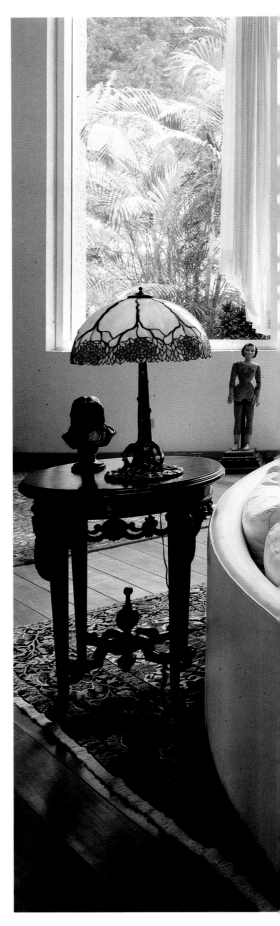

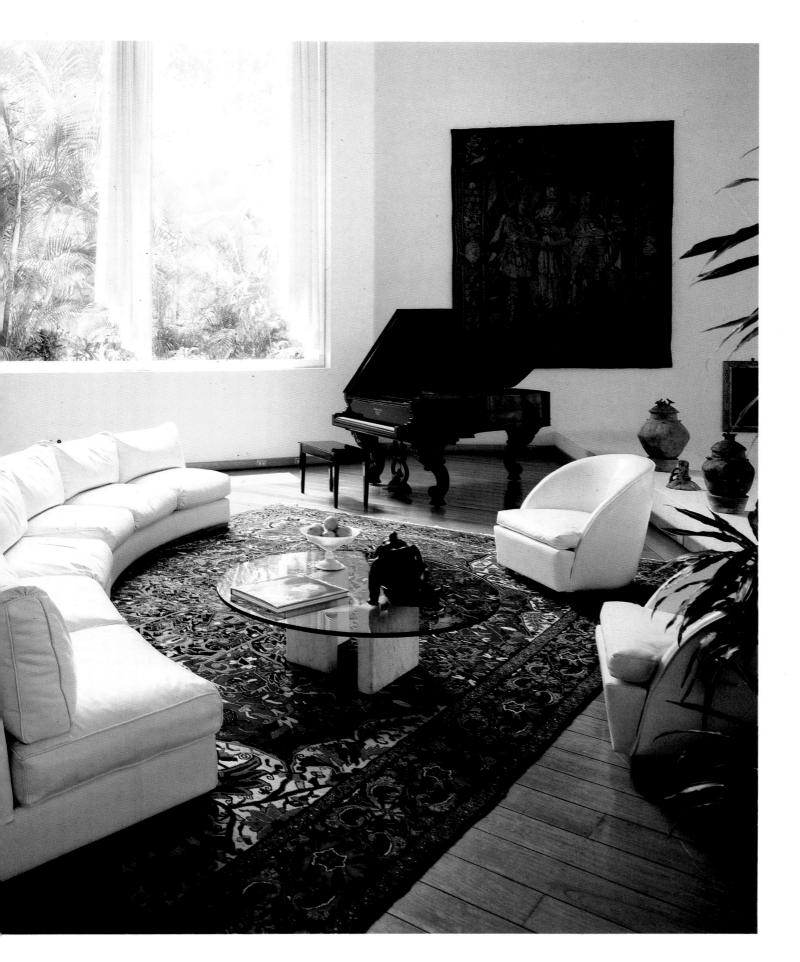

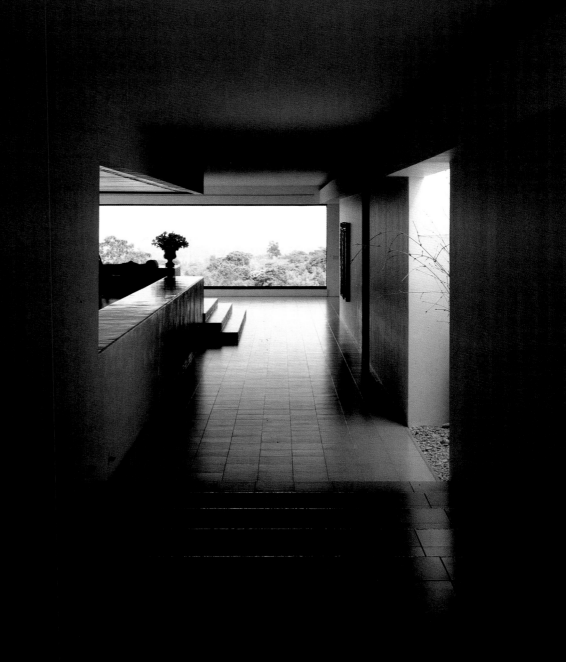

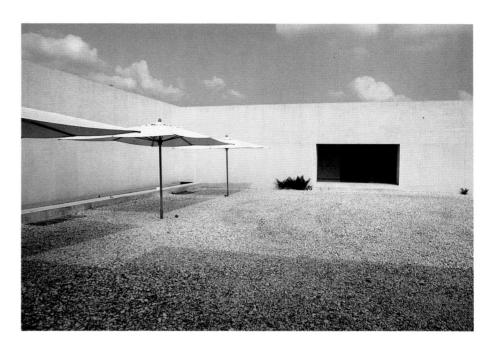

*Contemporary architecture in the tropics eventually creates
its own climate by concentrating on life indoors and by bringing
distant landscapes into the interior through wide windows.
The result reflects an exacting choice of materials, a nicely
controlled management of general lighting and of specific
luminescent points, ample spaces, and refinement in the selection
and placement of works of art and objects of special design
and form and color. The enclosed volumes on the outside
are covered with strong-textured materials that dramatize
the fall of the light and show up the sculptural character
of each object.*

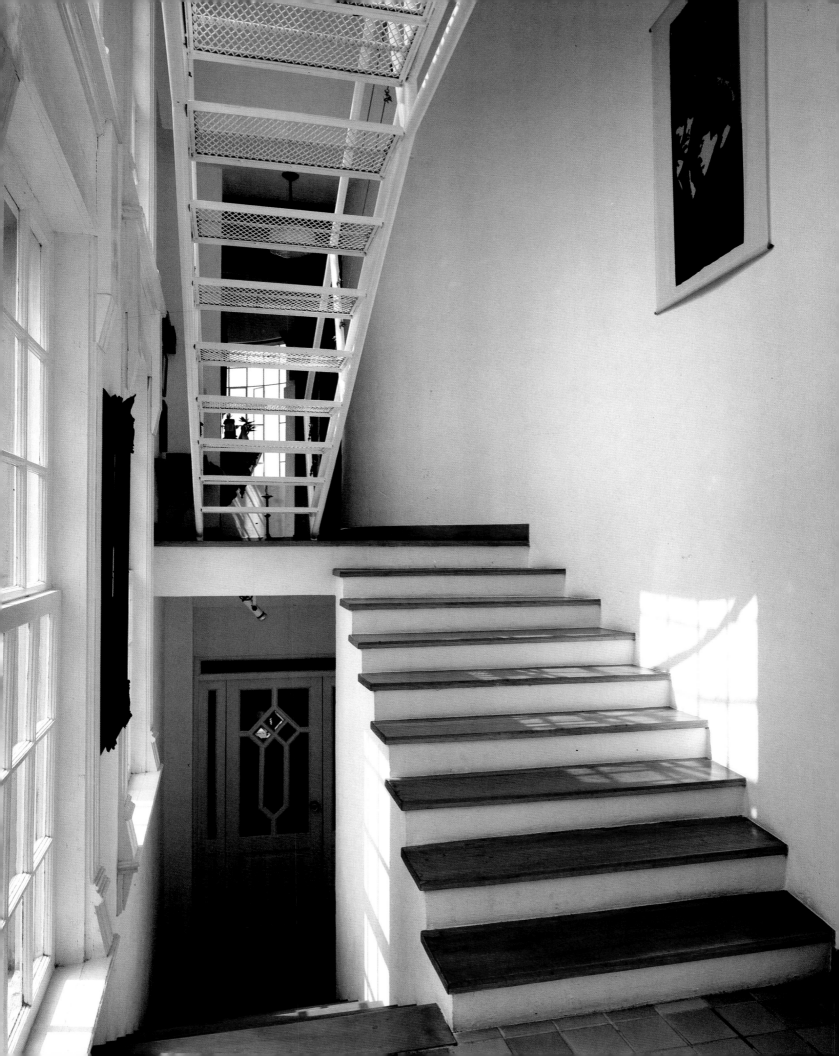

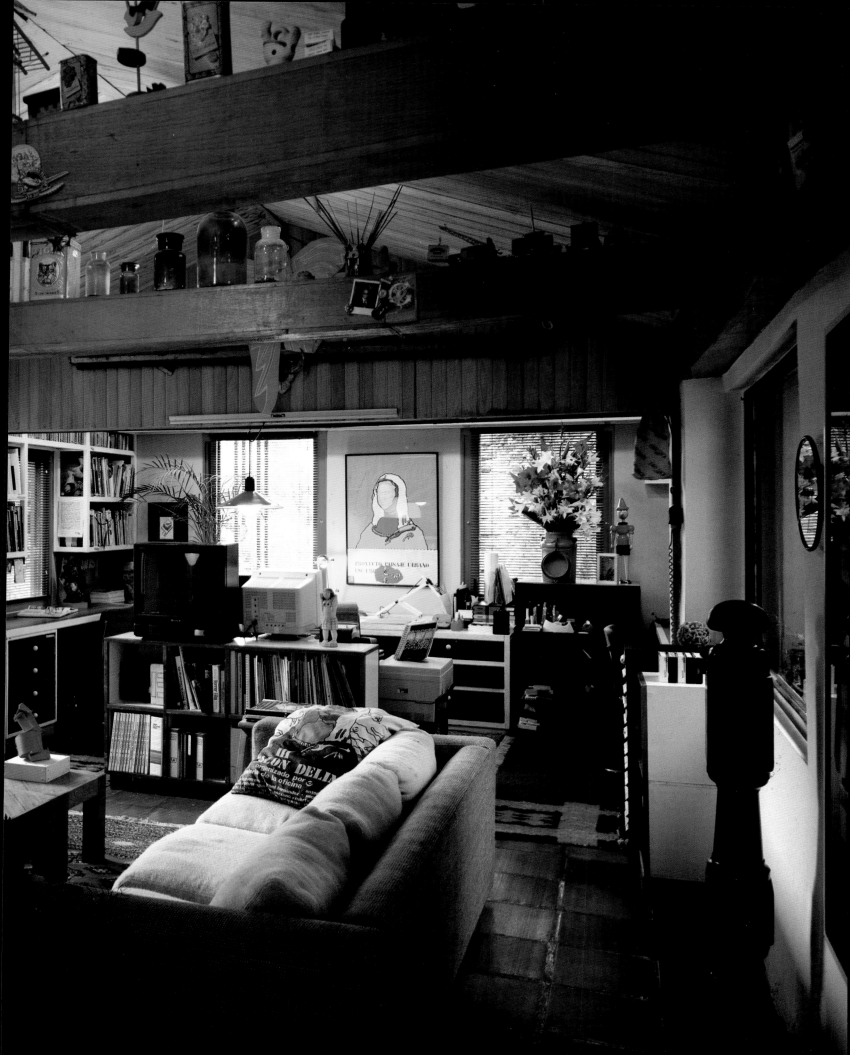

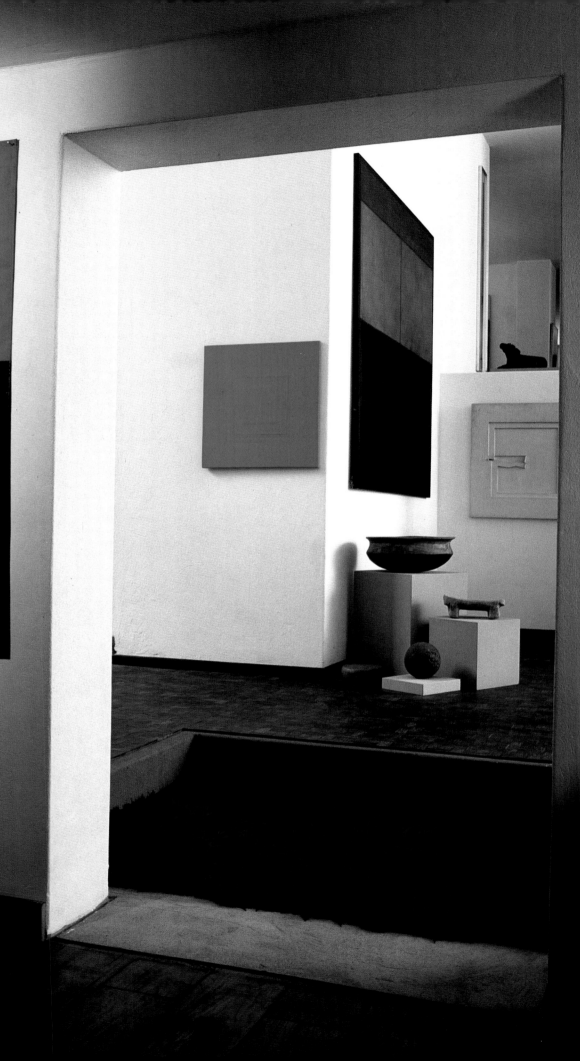

エドガー・ネグレ

EDGAR NEGRET

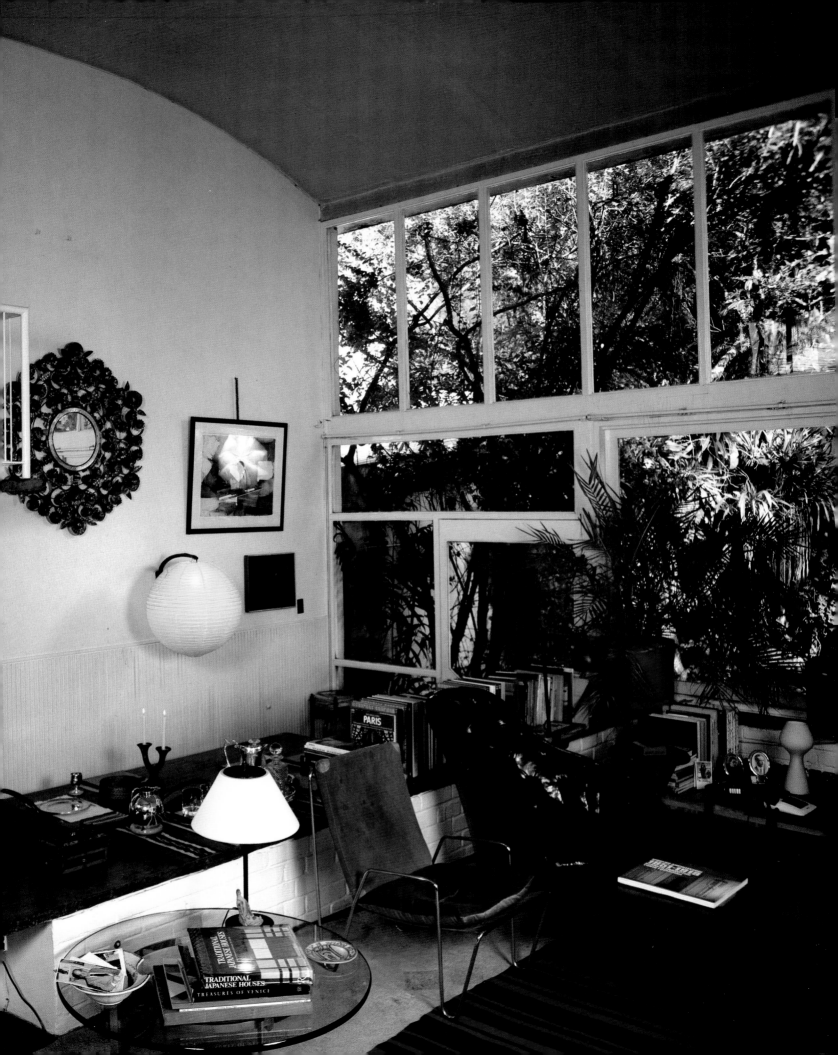

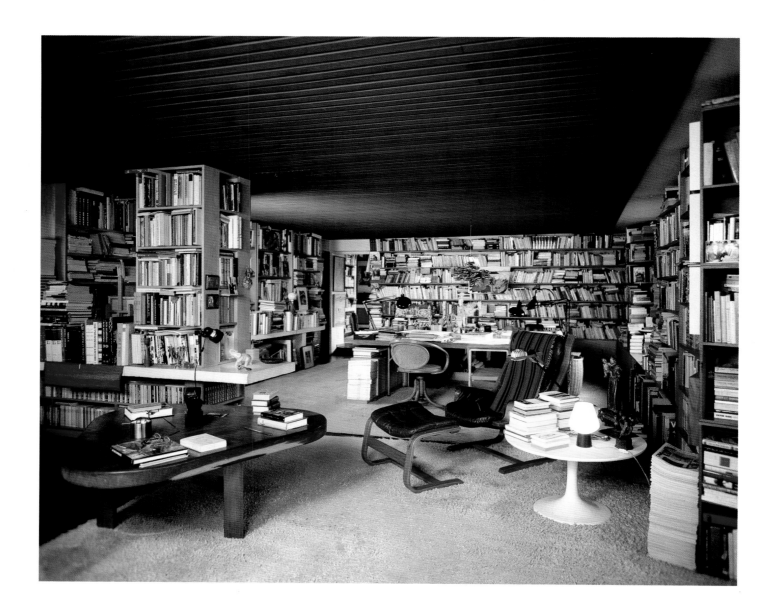

The concept of standardization in dwellings, which became prevalent in the 1960s, generated mixed reactions among Colombian architects. The confrontation between those who strongly favored technology and those who also wished to maintain the relationship with place, climate, region, and the particular temperaments of the proprietors resulted in a type of architecture that encouraged innovation as well as aesthetic possibilities hitherto untried, more efficient use of native materials like brick in the search for a new language at once traditional and contemporary.

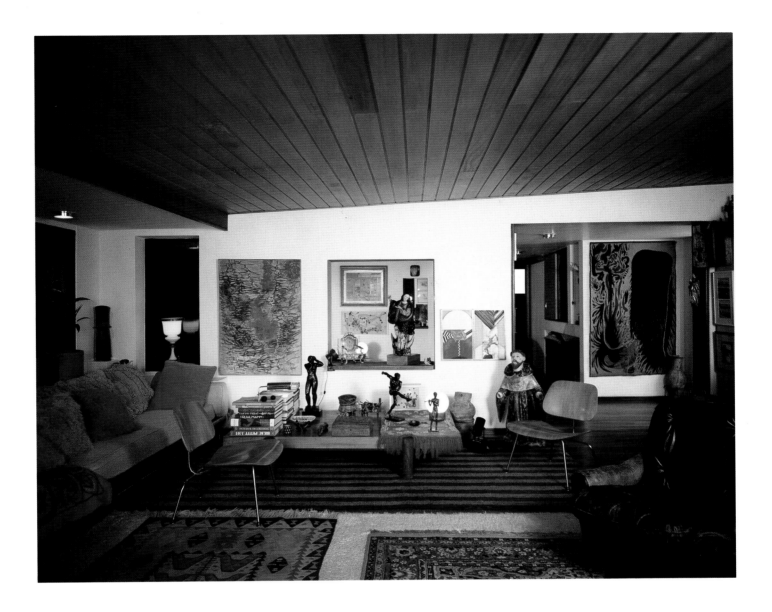

The architectural movement originating in Bogotá in the 1960s that favored an expressive language based on place, environment, and materials emerged in small buildings and single-family residences. The use of brick for the exterior of this type of construction is an affirmation of the insistence on a new free aesthetic, linked both to the landscape and to the sculptural shapes of the contents of the building. In the interior, books and objets d'art define the character of the areas, and although the furniture tends to be sparse, the impression is pleasant because each piece has been carefully chosen. These, then, are houses made for reading, for study and reflection, and for cultural gatherings and entertainment. These houses were intended for living with art, severe in conception perhaps, but also warm and daring.

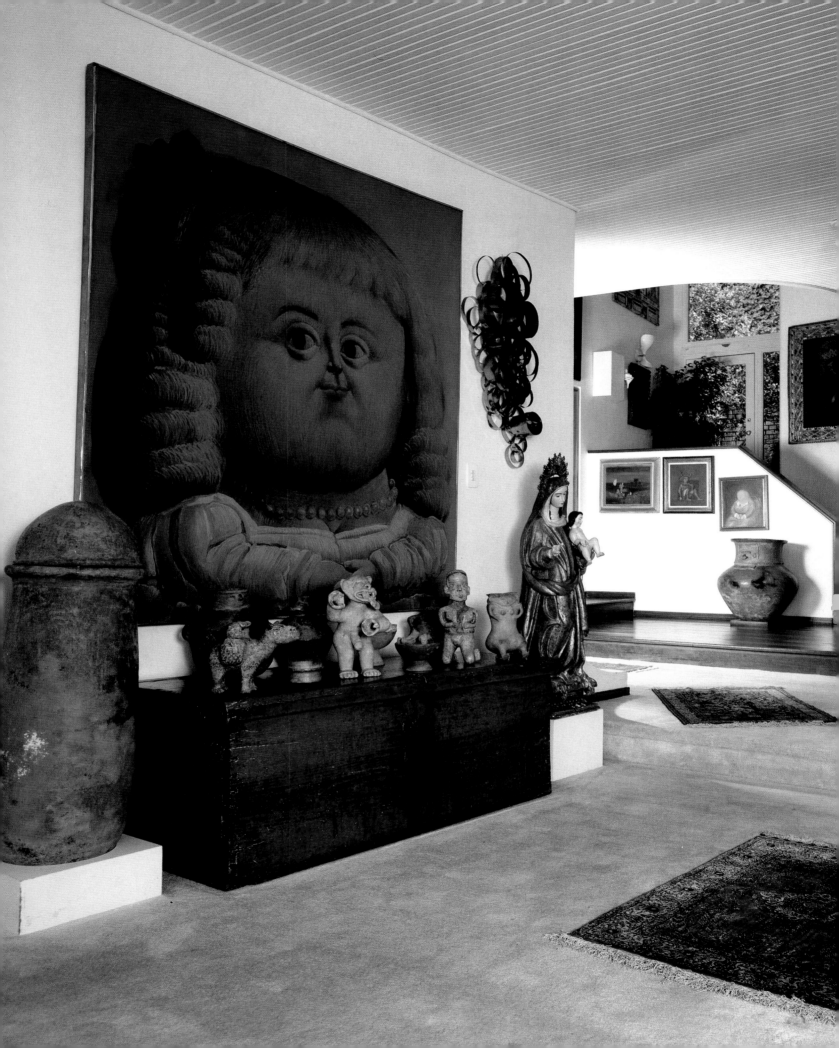

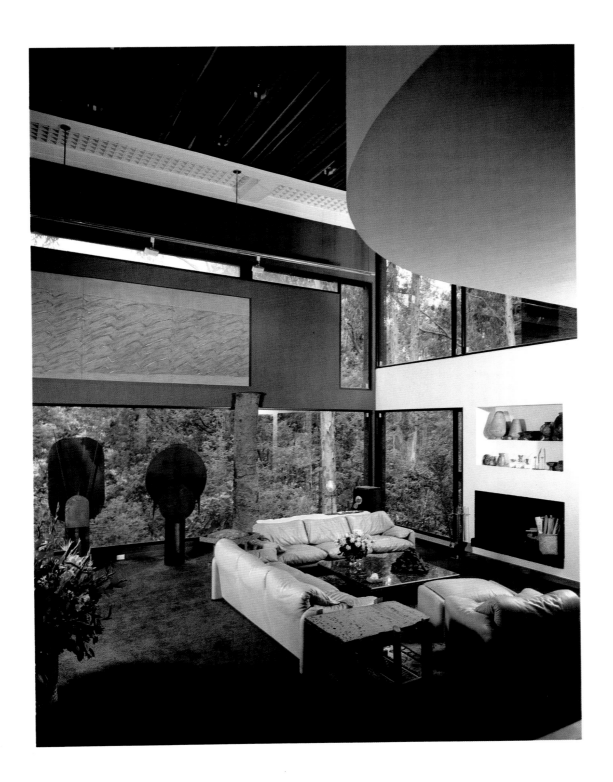

In the past, the character of a domestic atmosphere, its furnishings, and ornamentation were subject to the preexisting architecture. Today, with increasing frequency, the contents determine the form and quality of the living space, whether it be a search for greater flexibility and accommodation to the manifold distributions, in which the furniture defines function and appearance, or whether it be the placement of a work of art or some object of great value and significance as the starting point.

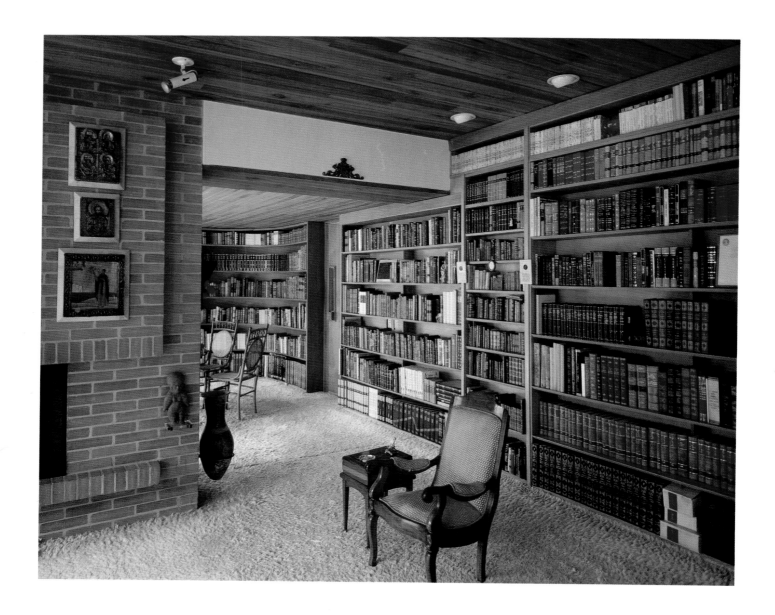

During the 1960s, architects in Bogotá began a search for an expression all its own founded on the resurgence
of local building materials and traditions. That search concentrated on brick as an economical material of
great aesthetic possibilities, a material that was being expertly handled by workmen and artisans. Until then,
it was seldom seen in interiors, and its use was limited to facades. A new attitude was necessary before
brick could be used in interiors, imparting to them an air of vigor and richness, and thus generating
an architecture of clear national origin that is warm and cozy as well.

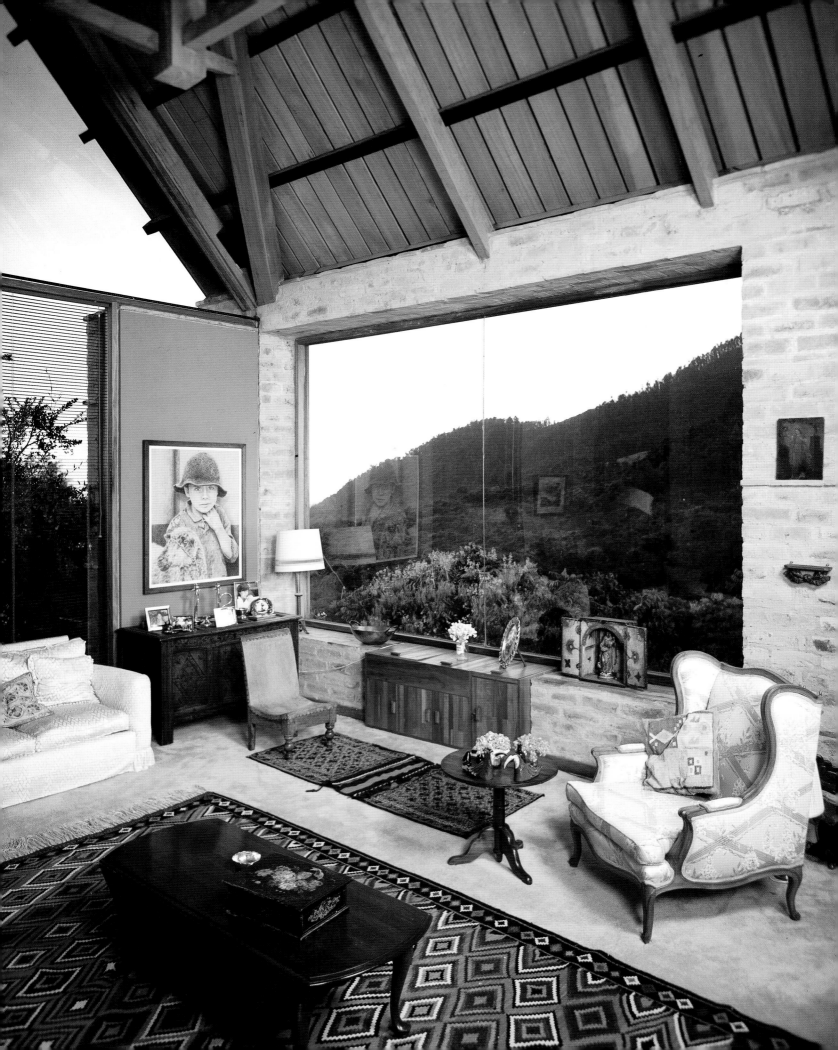

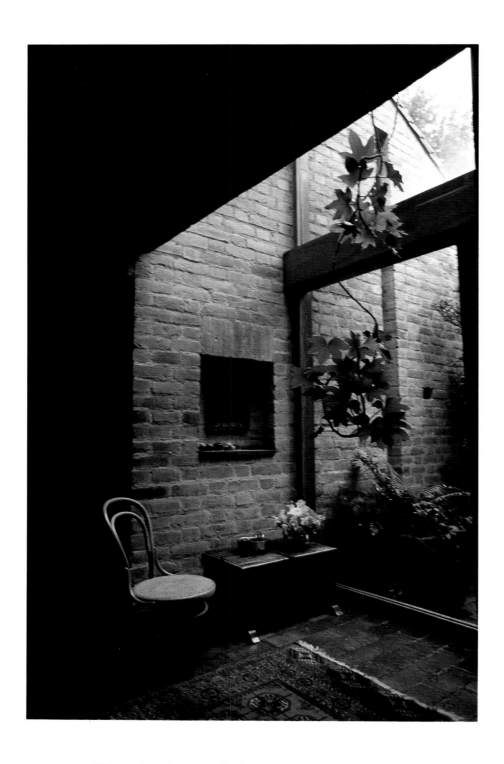

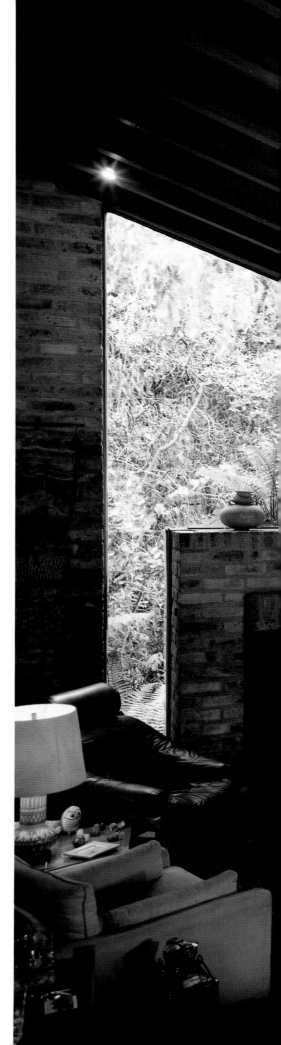

*The rural-style house of suburban Bogotá is cozy without
suggesting introversion. It is, in fact, open to the landscape,
and there is always some way for the sun-generated green
of the native woodland to enter through the window and add to
the sense of warmth, enlivened, moreover, by the fireplace.*

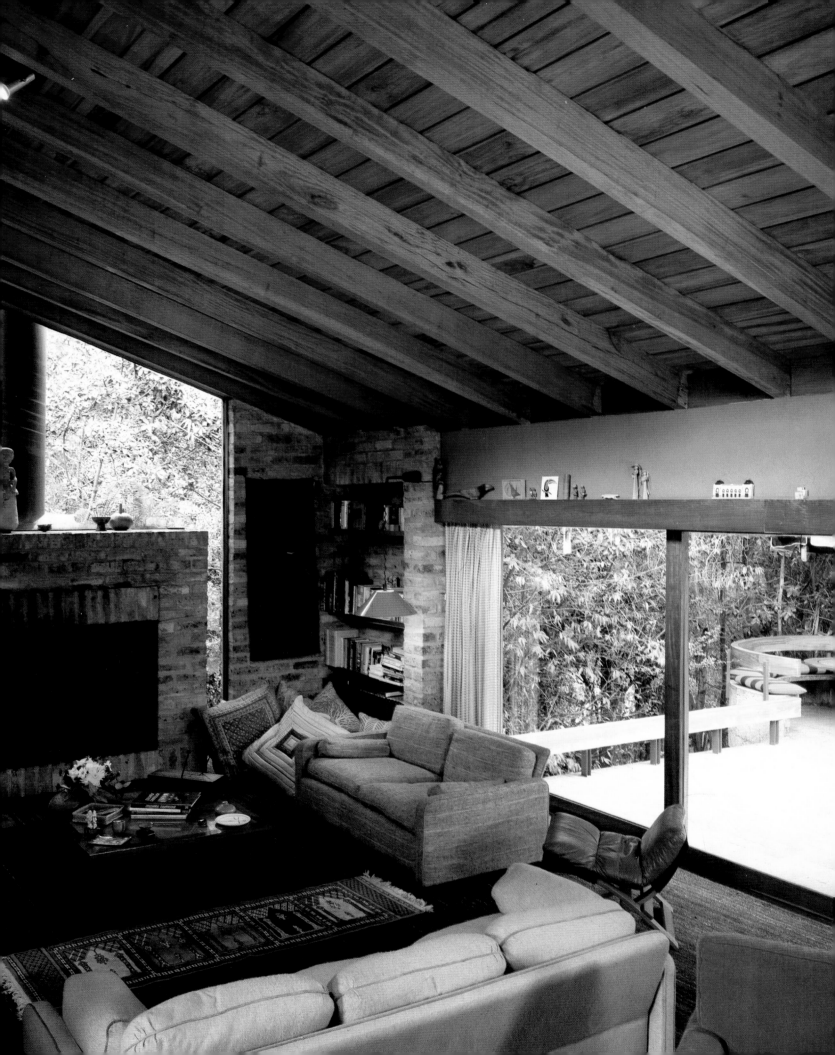

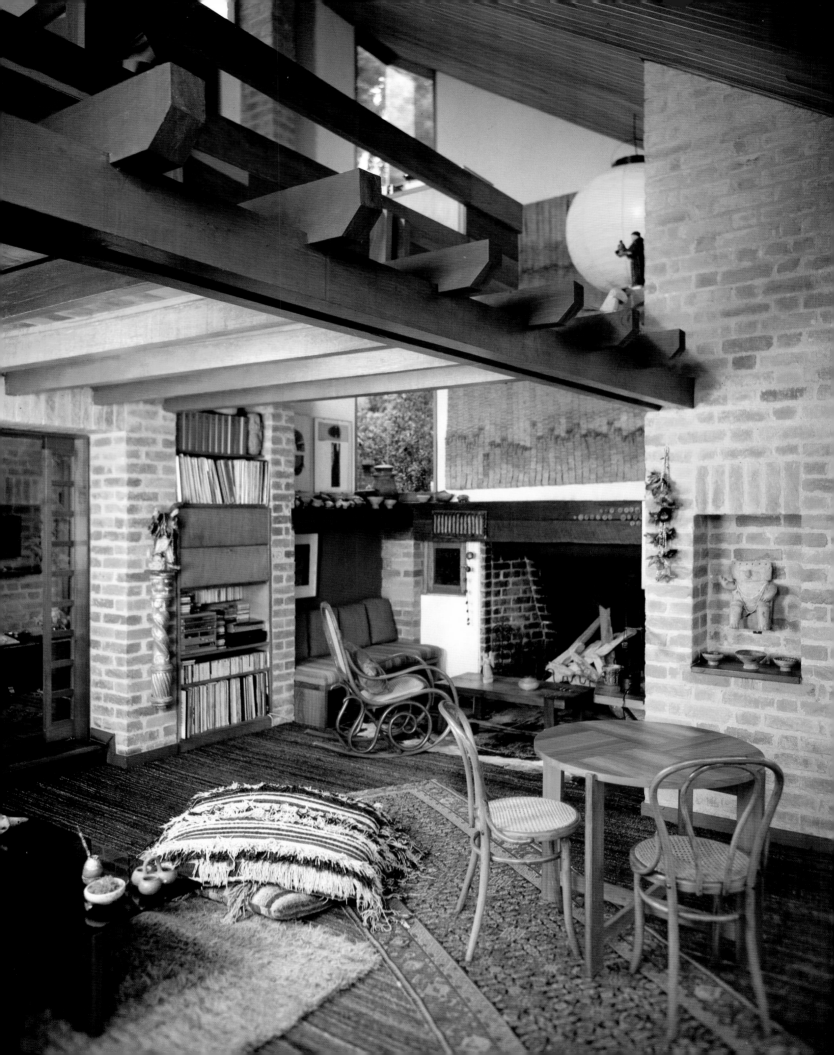

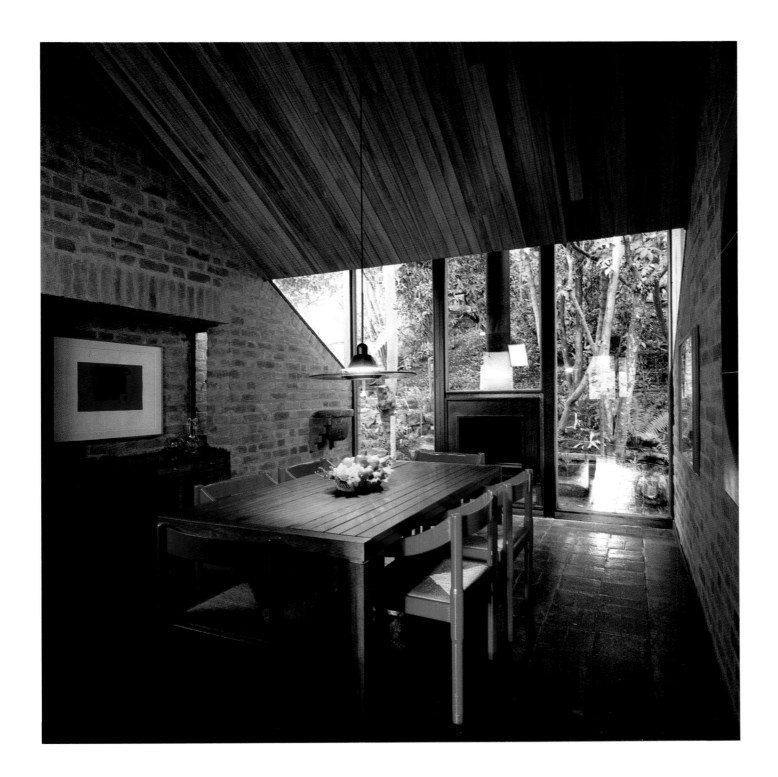

As an inheritance of the architectural movement in Bogotá in the 1960s, brick acquired added dignity in the
hands of the following generation. Its use has become greater, but at the same time more meticulous and more
expressive. It has entered the interior of the house, where the living space has been conceived with due regard
to its physical and even its tactile qualities. Its color, texture, and affinity with other native materials
constitute a basic element in this architecture while appealing to the senses, and its evident kinship to wood
and rustic textiles exalts their common artisan origin and reinforces the domestic atmosphere.

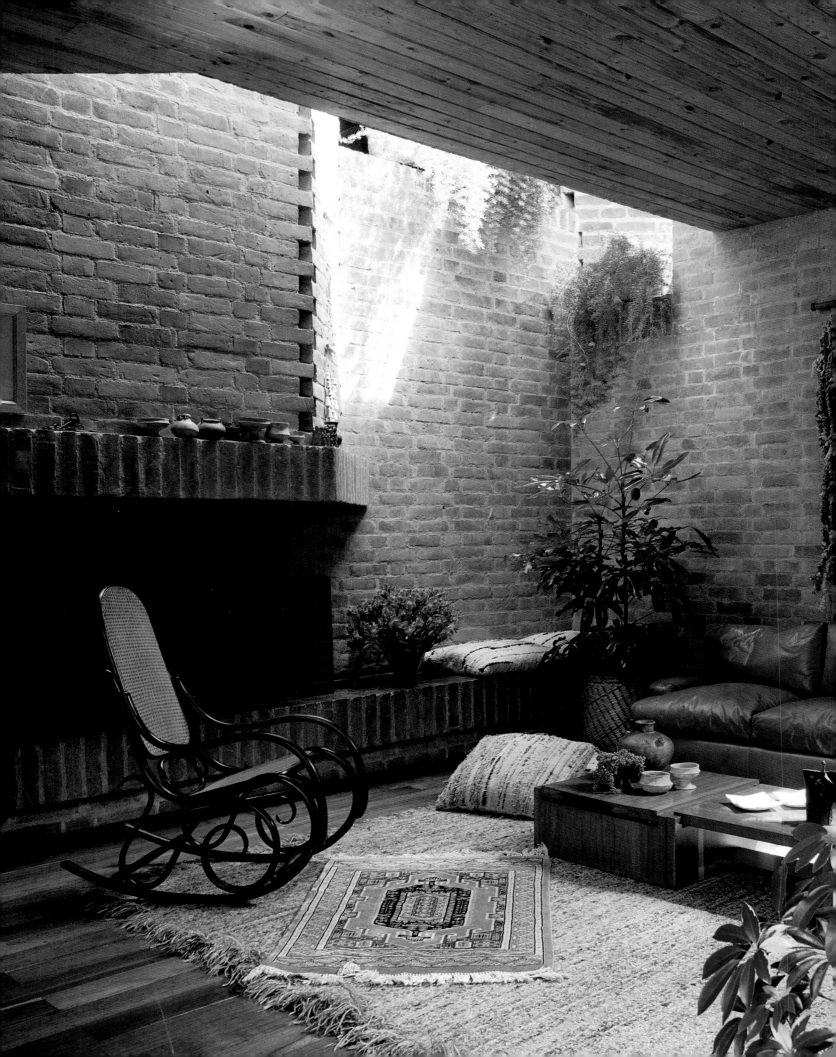

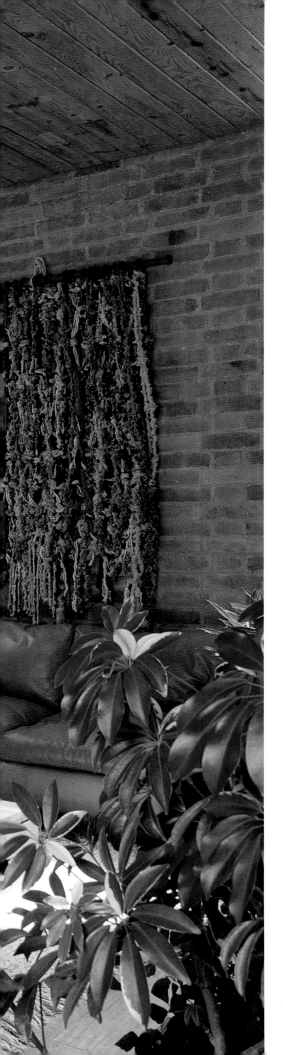

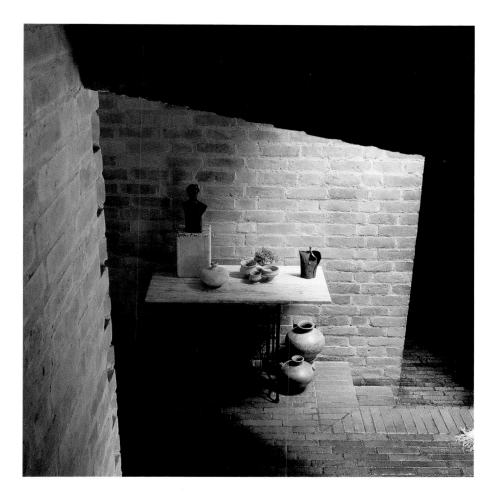

The suburban architecture of Bogotá expanded in the late 1970s
as a result of the rapid growth of the city. In the green landscapes
of the high plateau, among patches of native woods in the hills
and mountains, some excellent examples of an austere and refined
architecture are found. The exposed use of materials such as brick
and wood and the careful study of light devices are some of the
features of this house. Apart from large windows that frame
the landscape, skylights used as windows to the sky allow
soft light to enhance the texture of the walls and the presence
of plants and objects.

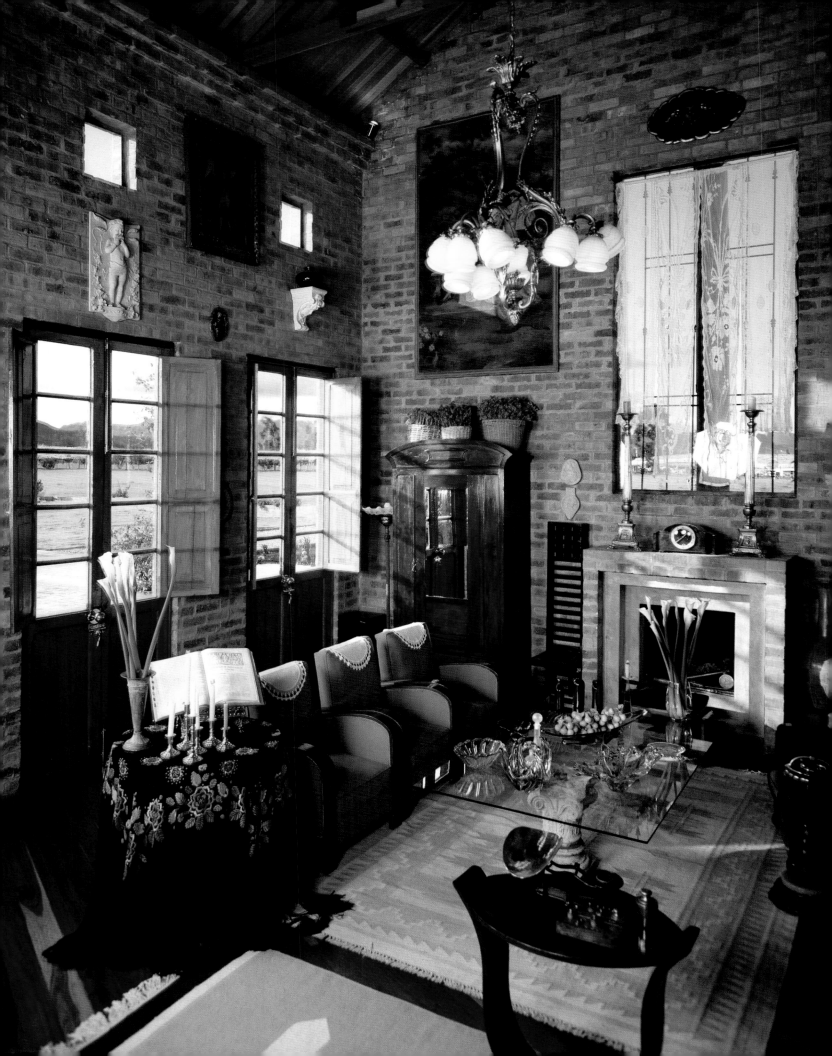

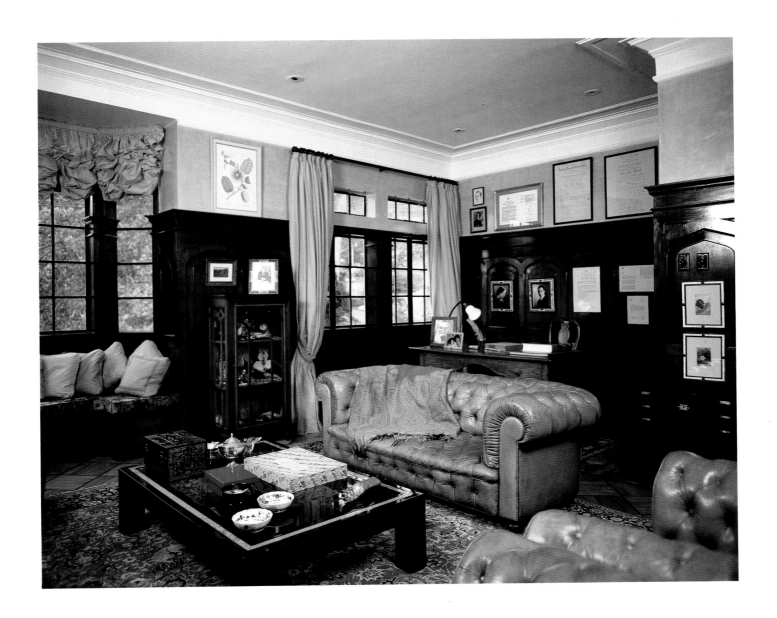

Houses in Bogotá's traditional residential districts that retain their original domestic function are a faithful testimony to the past life, customs, and aspirations of the society of the capital. They were built by architects and by engineers skilled in matters of style, assisted by master workmen and artisans, who had refined their ancestral ability to the point of displaying exceptional excellence. Every house, in accordance with its style, shows a marked coherence between its facade and the treatment of its indoor areas. This unity encompasses the furniture as well as the source and quality of each of the objects and works of art that accompany it.

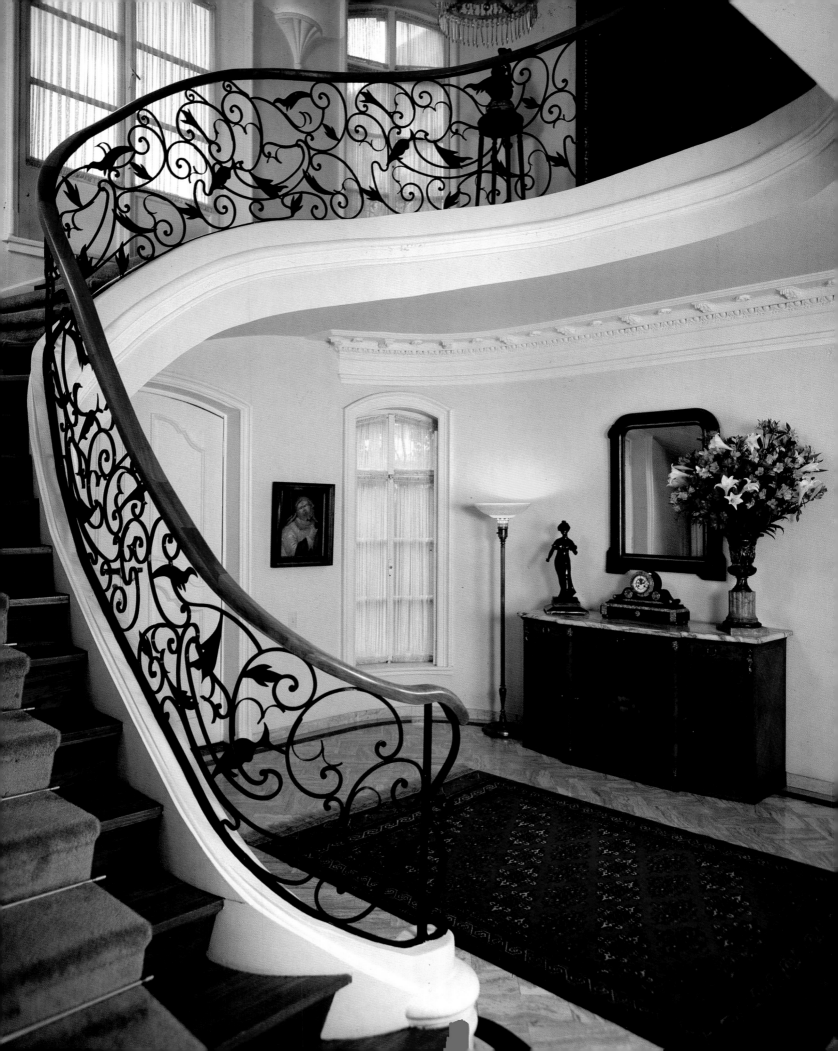

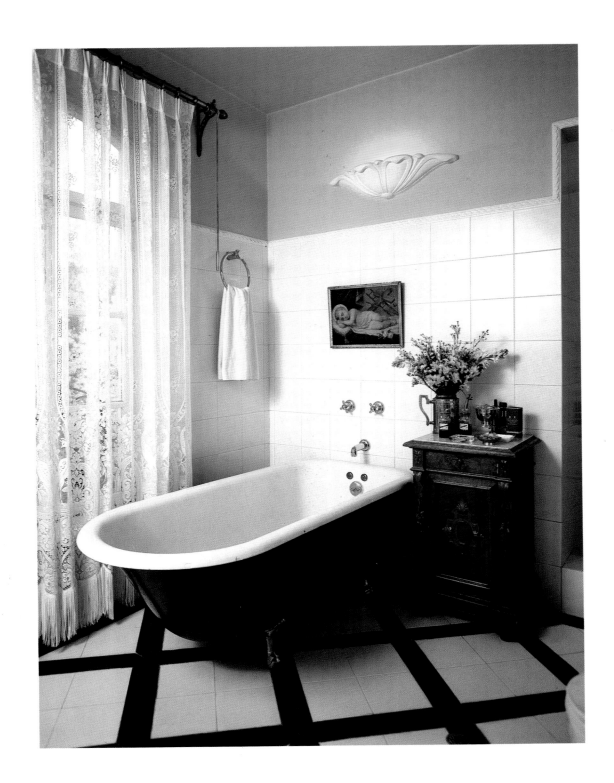

*During the transition to modernism, architecture dominating Bogotá's
residential quarters in the second half of the twentieth century found its happiest
expression in a noteworthy interpretation of the French neoclassical style that
integrates the valuable documentary repertoire of the capital. Here is an
architectural recovery effected with conscientious regard for the elegance of
the spaces, the artistic value of the ornamental products of plaster
and the forge, and the faithful restoration of every room in the house.*

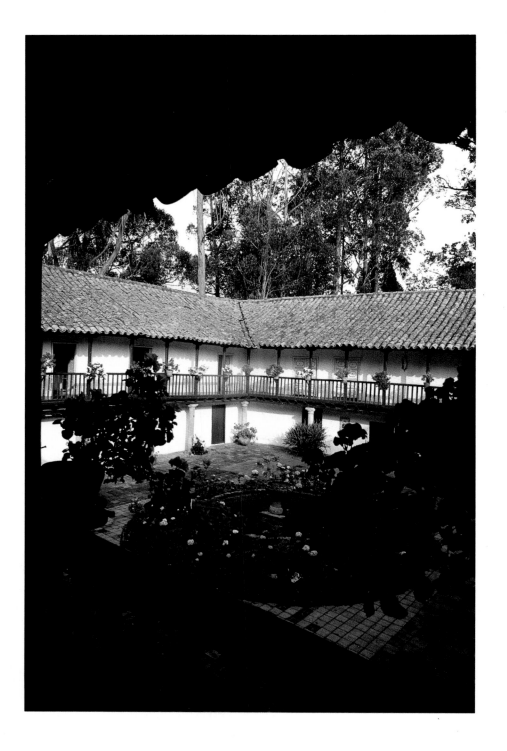

Having undergone successive alterations, in their present state few
great houses of the estates on the Bogotá Plateau can be
considered historical or stylistic relics of the Colonial period.
Some of the larger ones fortunately retain the essential values
of the Colonial style not only in their facades but also in
the cloisterlike aspect of the large patio, surrounded by balconies
and alive with ivy and geraniums, and in the rigorous
composition of their roofs.

MADRID, CUNDINAMARCA

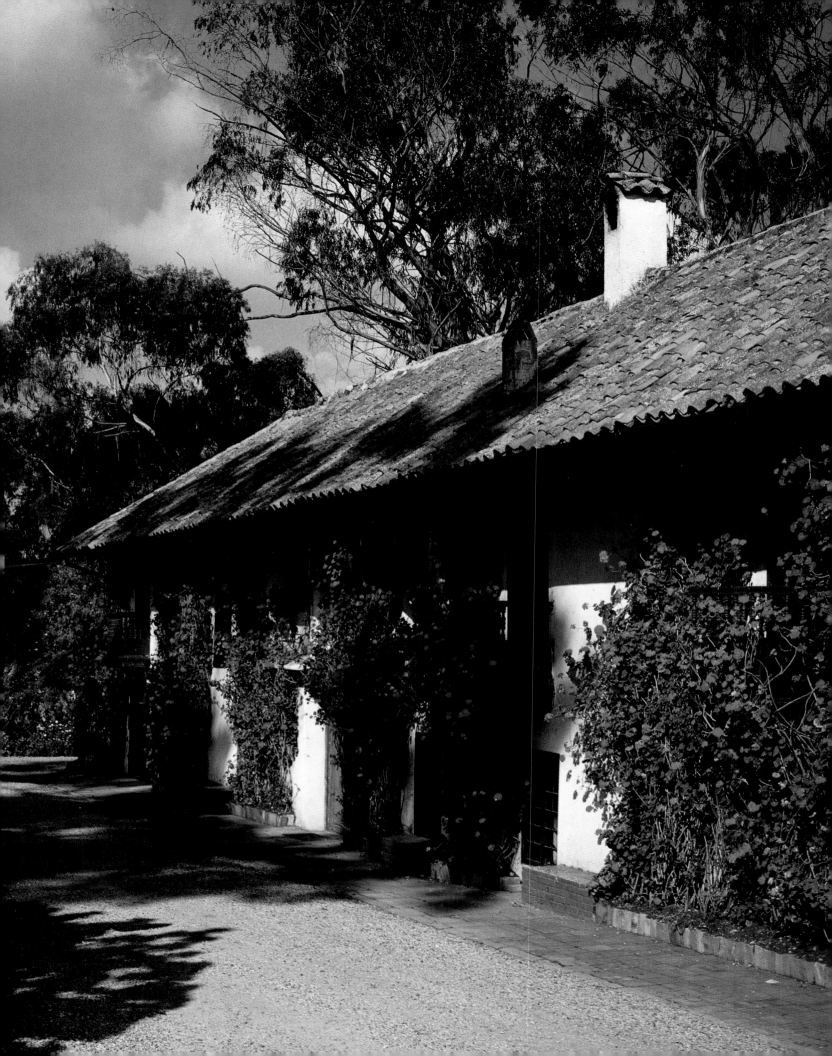

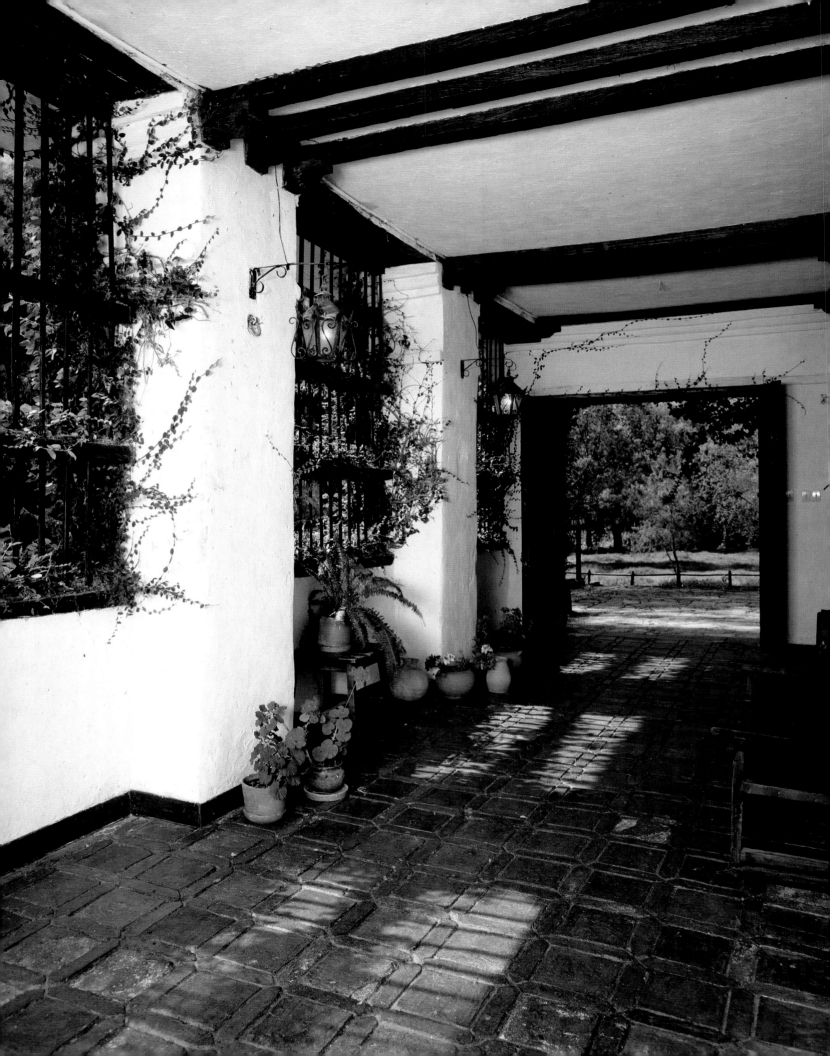

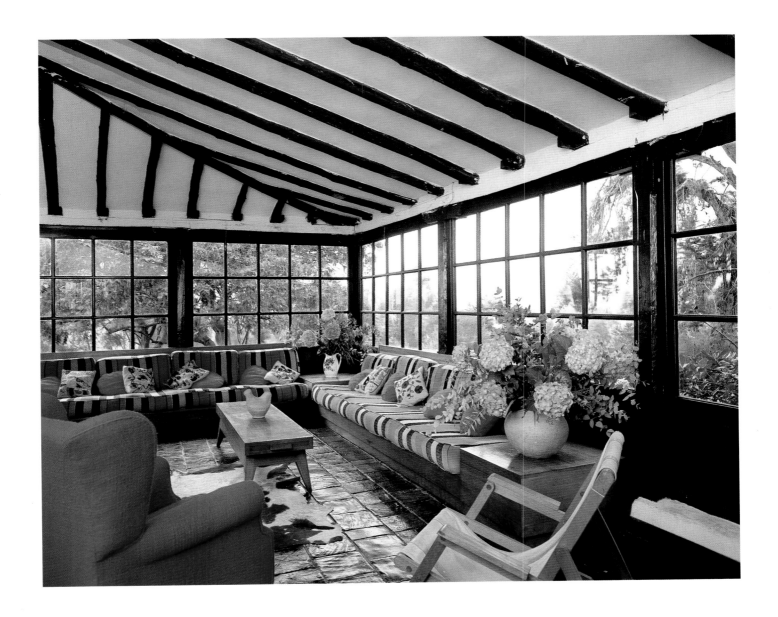

Modern life led in rural estate houses has necessitated the constant adaptation of spaces to serve new purposes. Because of the impossibility of satisfying modern needs in the original living space, there has been an adaptation of patios and passageways. Storerooms and places originally intended for agricultural chores, all independent of the main body of the house, have also been pressed into service. A serious attempt is always made to adhere to the existing form of construction and reproduce the original distinctive features of the house, even while providing it with the greatest possible contemporary conveniences and comforts while affirming a relationship with the landscape.

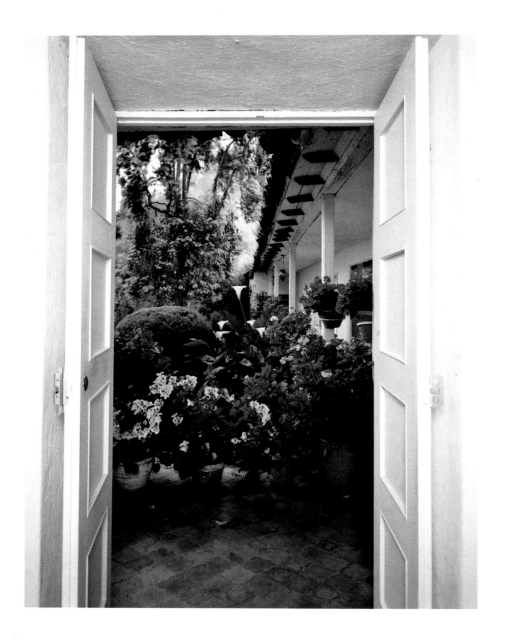

When modernizing the savannah house, the need for greater comfort and a freer and more direct relationship with the landscape join hands with the intent to retain the original structure and those features that perpetuate its tradition. This coexistence enriches and defines the nature of the second life of the house. Woolen caparisons *have left the backs of horses to be sewn into the form of colorful rugs. White paint endows the roof frame with a sublime quality. Wide windows capture all the shades of green in the garden, and, in the backyard, such native flowers as the* cartuchos *(calla lilies) and geraniums maintain their ancient bond with the peasant's house.*

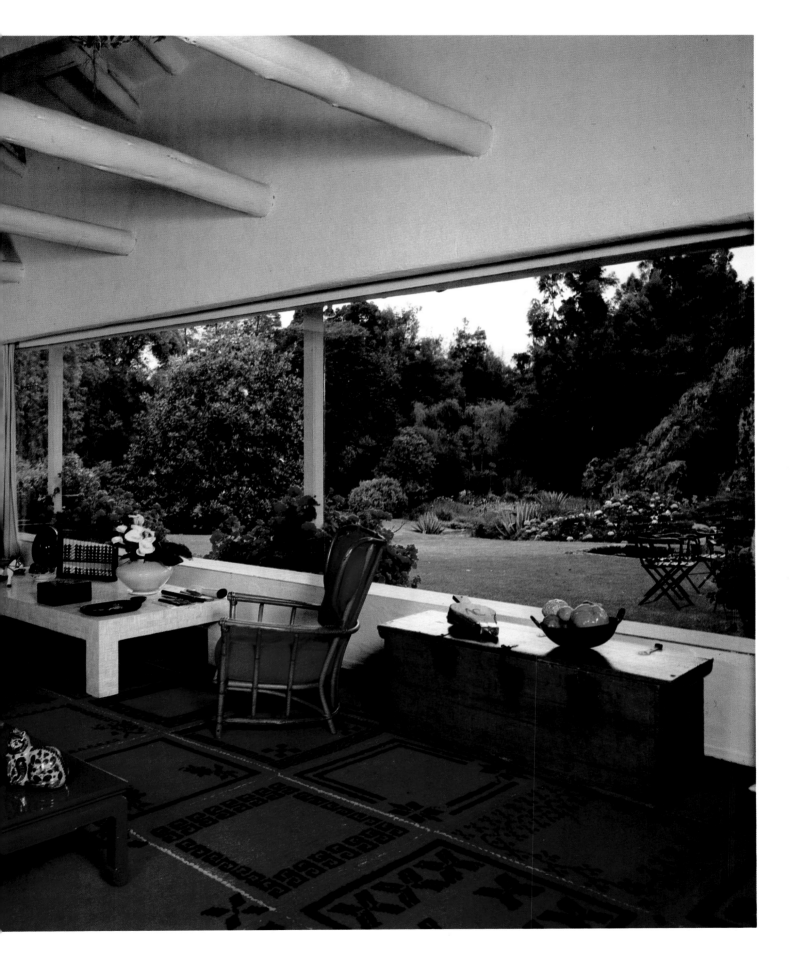

TABIO, CUNDINAMARCA

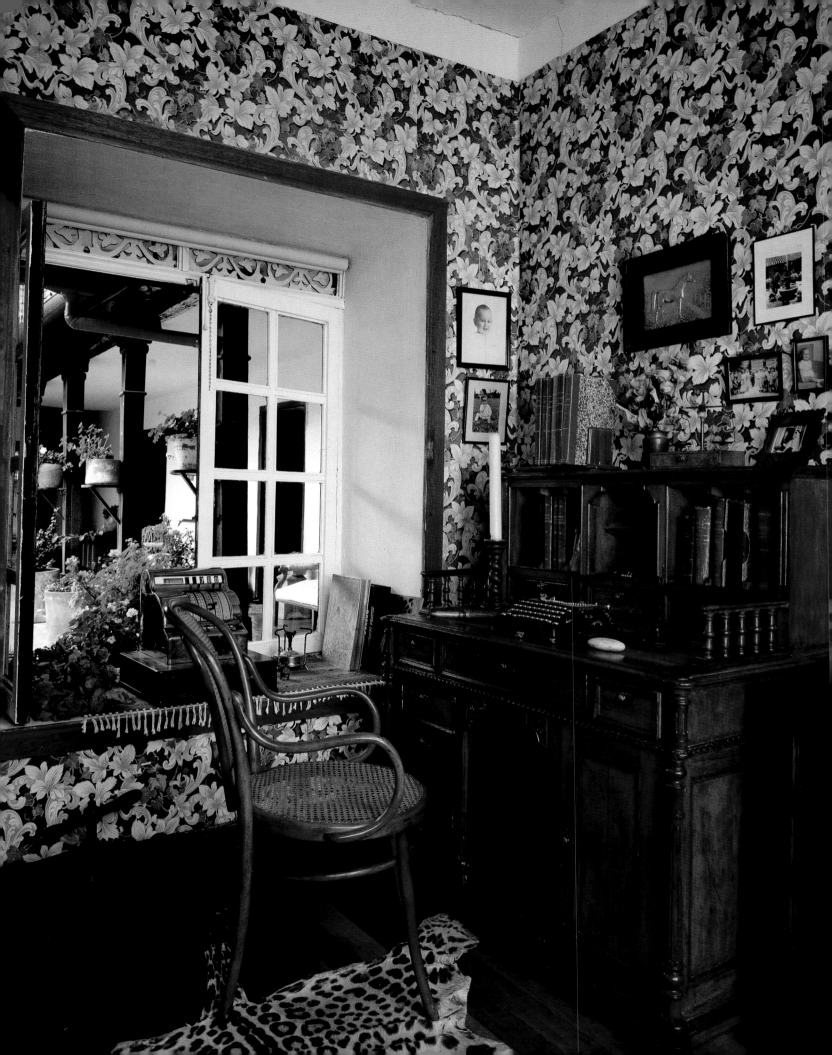

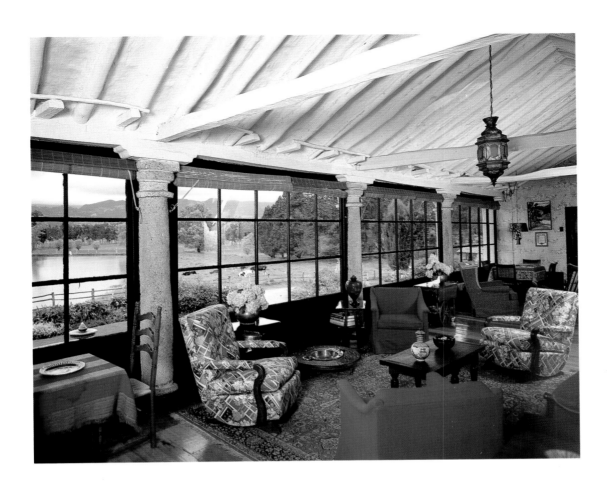

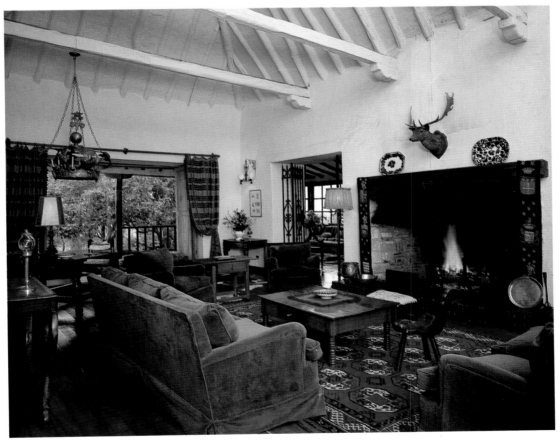

SAMACÁ, BOYACÁ / ZIPAQUIRÁ Y TOCANCIPÁ, CUNDINAMARCA

165

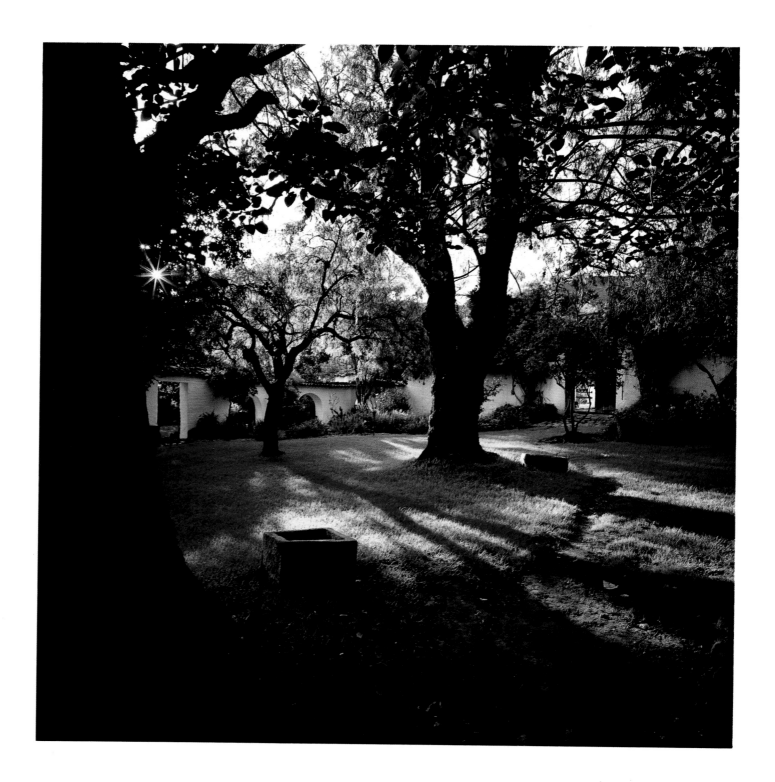

*There are no fixed rules in the formation of the house garden of the landed estates. Its evolution has been
so subtle that the strict cultural notion of a garden loses its validity here in the milieu of the countryside.
This spontaneity is perhaps the source of its beauty, resting as it does on the green permanence of the lawn,
on the age-old presence of a tree, or on the adobe wall that encloses it.*

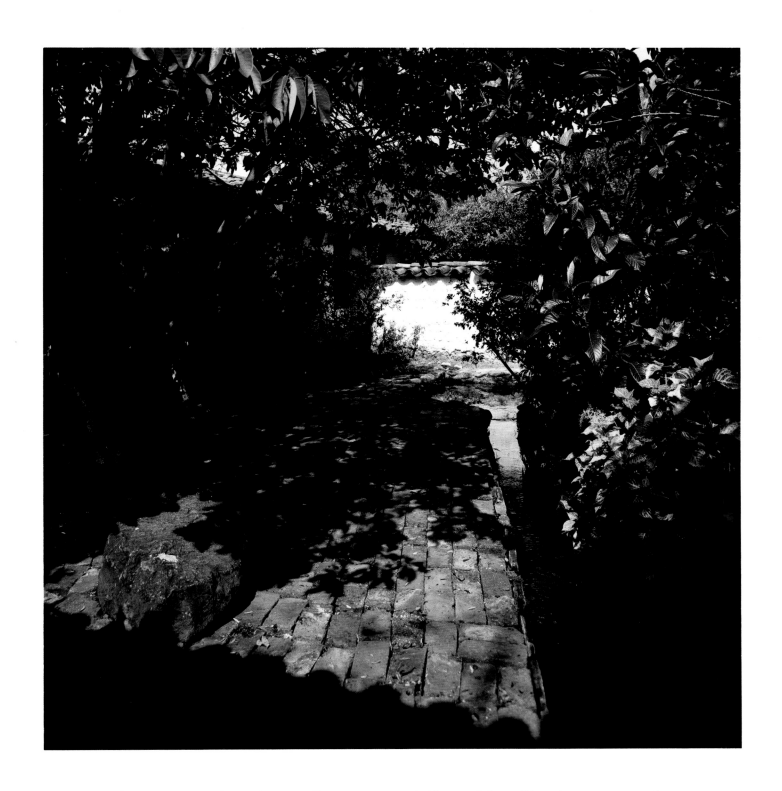

An intimate area of a rural house in Boyacá is surrounded by an adobe wall in order to create a garden.
Thus it forms a neighboring landscape that borrows from the surrounding native shrubs and nearby stream,
which, channeled through little ditches, gladdens the house on its way back to the dell.

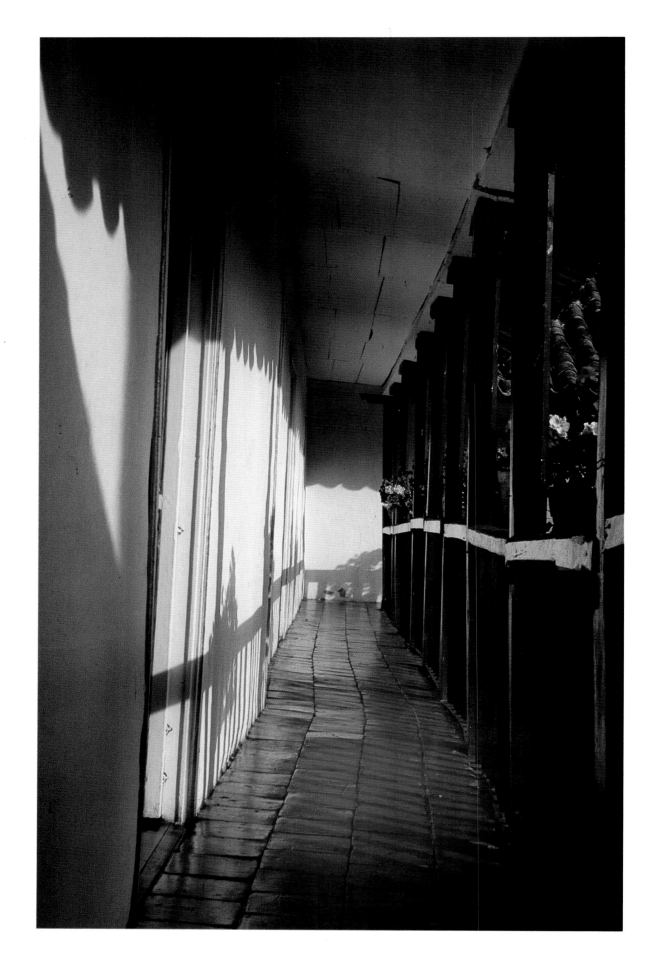

MADRID, CUNDINAMARCA

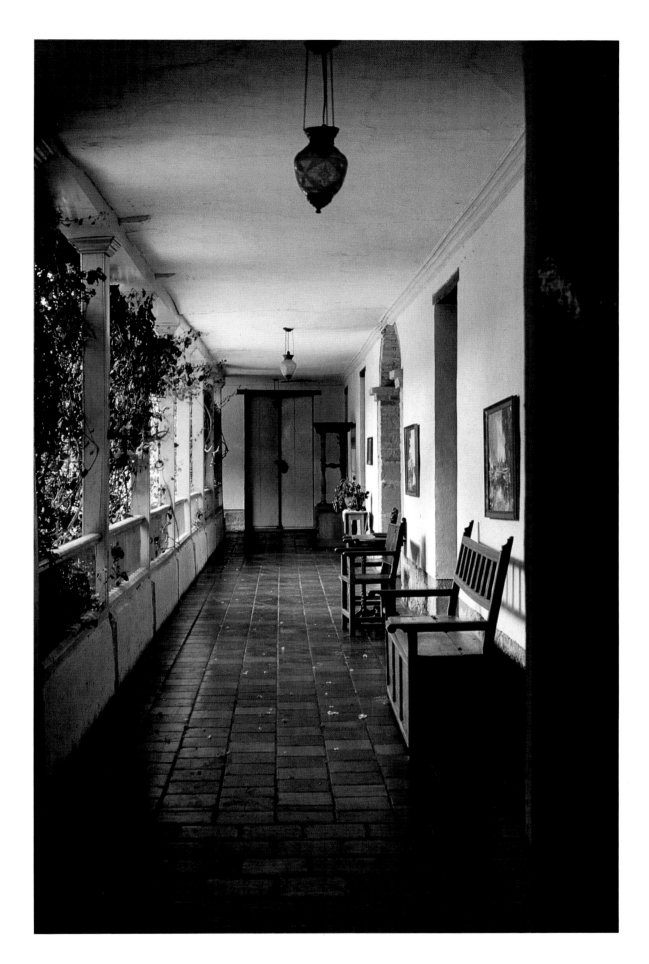

SIMIJACA, CUNDINAMARCA

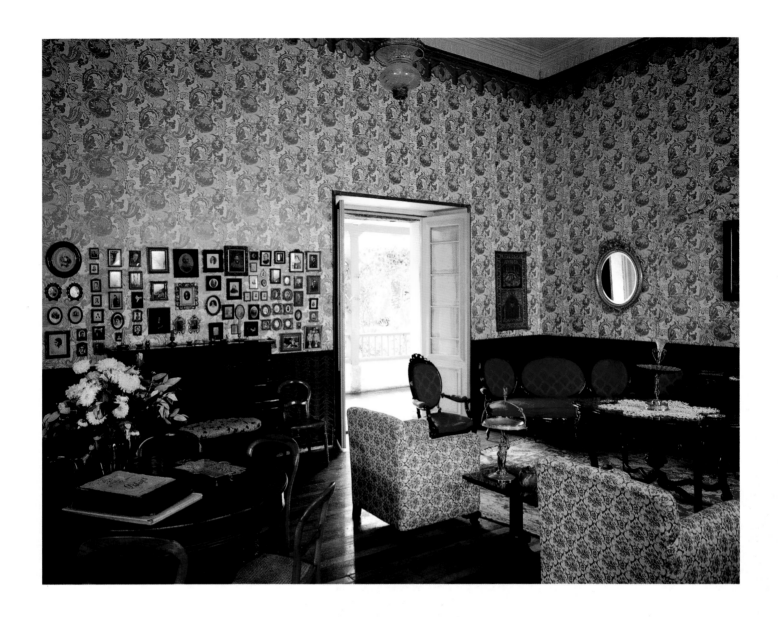

Some of the larger colonial haciendas, or estate houses, built in the seventeenth and eighteenth centuries are located in the high plateaus of the eastern range of Los Andes mountains, in the states of Cundinamarca and Boyacá. The architecture of these houses is of the central courtyard type with surrounding corridors. In late examples, the French and English architectural styles, brought by illustrious architects, added some refinement to the general conception of the house and to its details. In these rooms it is possible to appreciate the decorative taste of the late nineteenth century.

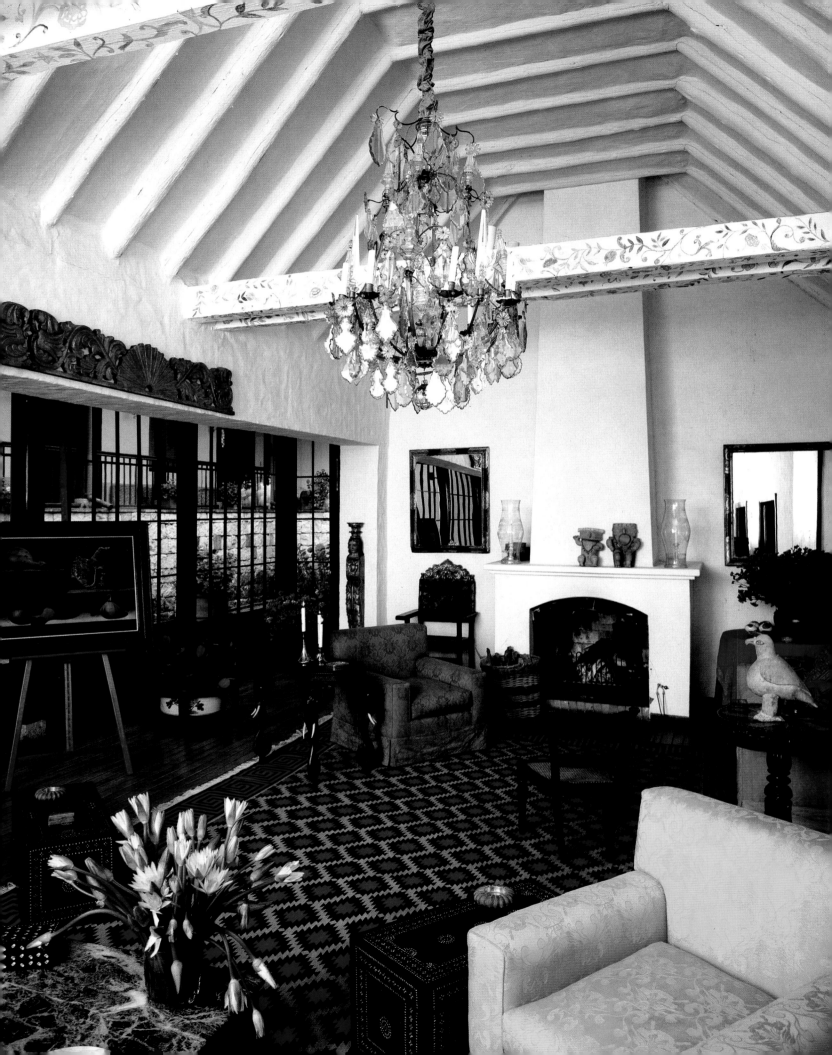

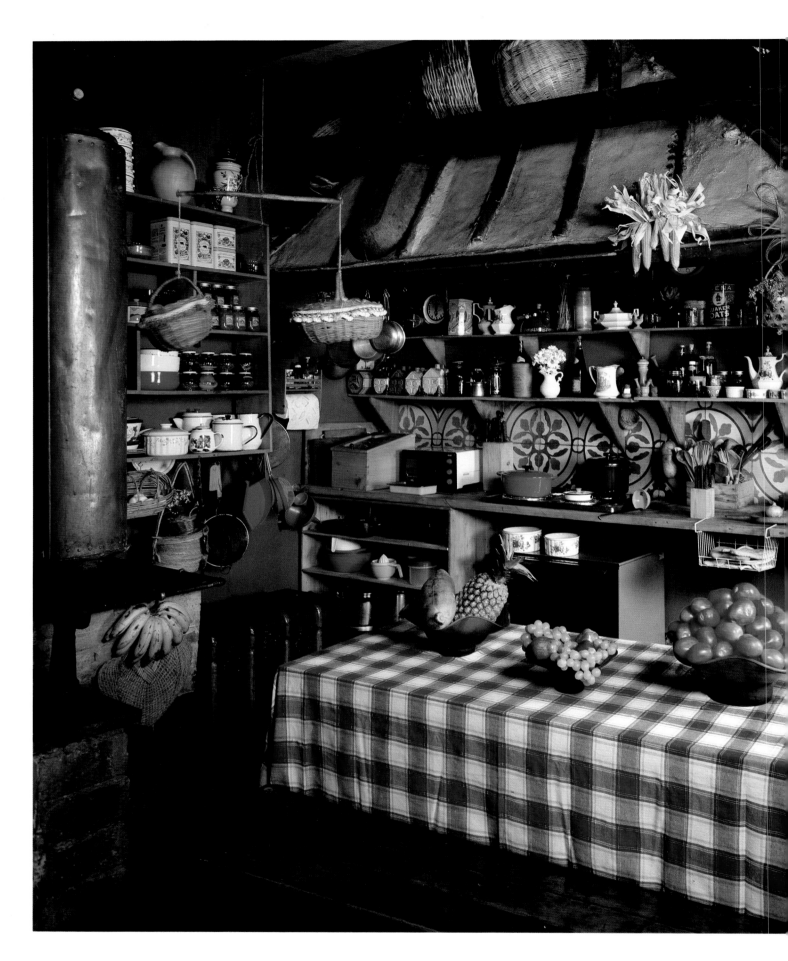

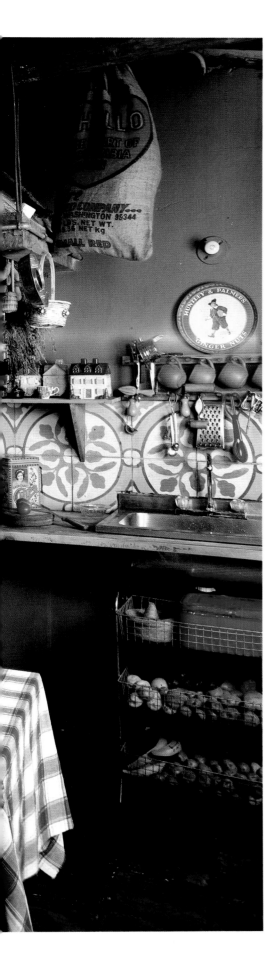

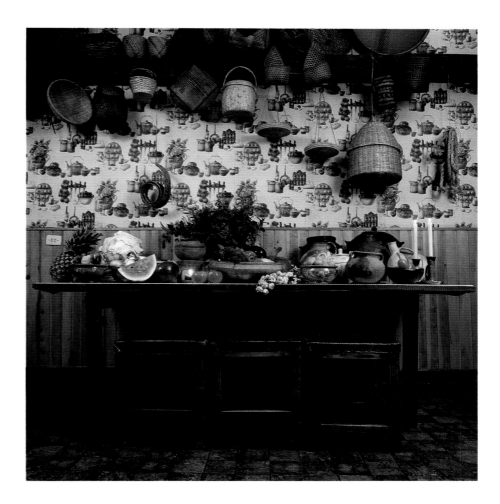

An upsurge of love and evocation of domestic customs
is to be noted in the restoration of the kitchens in the center
of Bogotá and on the savannah. Particularly outstanding
are the multicolored details and ornaments, with their
heterogeneous character and frank anachronism, as artistic
items emphasizing identity and celebrating native
handicrafts such as pottery and wickerwork.

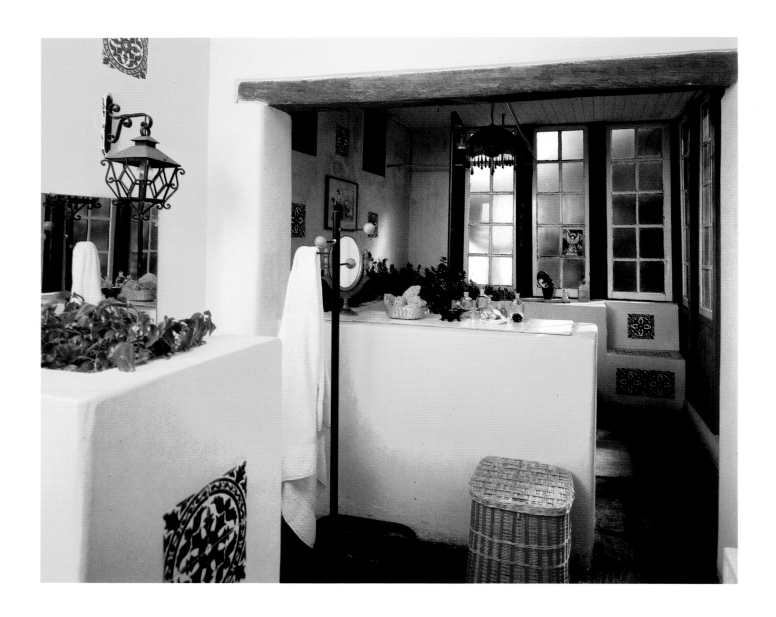

Restorations in the center of Bogotá vary according to the type of house, its recorded past, its architectural value, and the sort of life looked forward to by the new inhabitants. Most of them are to be found in the quarter of La Candelaria, and although their configuration is reminiscent of the Colonial style, it is not difficult to recognize the Republican stem in their architectural and decorative features. The few mansions that had not already been given over to other purposes were restored as single-family residences. Most of the others have become apartment houses, which, even so, jealously retain the traditional entry and corridors to perpetuate their pristine character. This labor of adaptation and modernization is to be admired equally for the respect it has evinced for the past, for a painstaking and thorough endeavor to repair and improve, and for the accommodation of space to contemporary comfort and aesthetics, in a manner quite suffused with the mellow charm of Santafé de Bogotá.

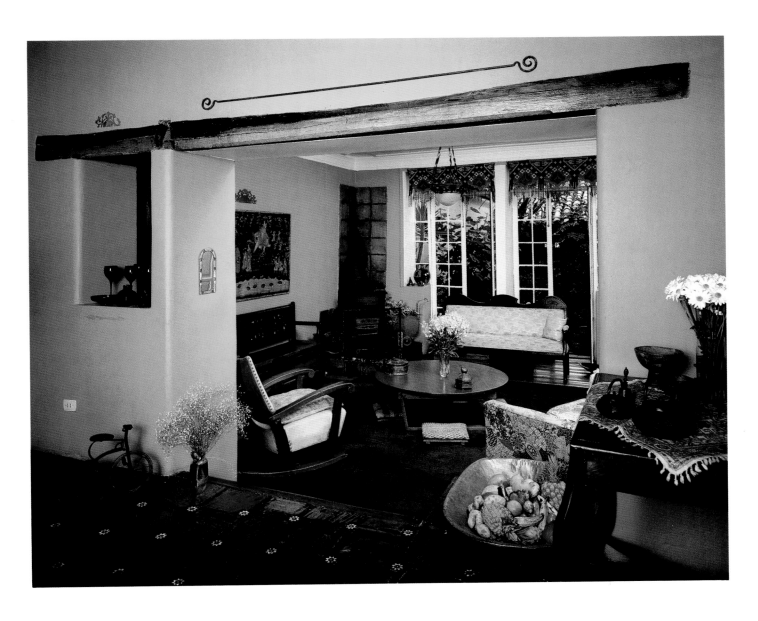

As soon as the residential house was identified as the most important factor for revitalizing the historical center of Bogotá, there were various attitudes about the way to tackle the restoration and modernization of its living spaces, necessary, indeed, to make such a recovery attractive, prevent new migrations, and consolidate the existing cultural and artistic manner of life. It was easy for everyone to agree that the interior should be warm and comfortable, even at the expense of altering its configuration. On the other hand, out of respect to the external appearance and its relationship with the public space, due to a curious municipal provision, the whole of the documented architecture of the old section had been given a certain uniformity by means of the dark green color of the woodwork and the white of the flat surfaces of the facade. It was necessary, as in Cartagena, to turn to scientific research in order to uncover, under the whitewash, successive coats of paint, bearing witness to a senseless suppression of the chromatic freedom of facades, balconies, and balustrades, a freedom which now once more enlivens public space in La Candelaria.

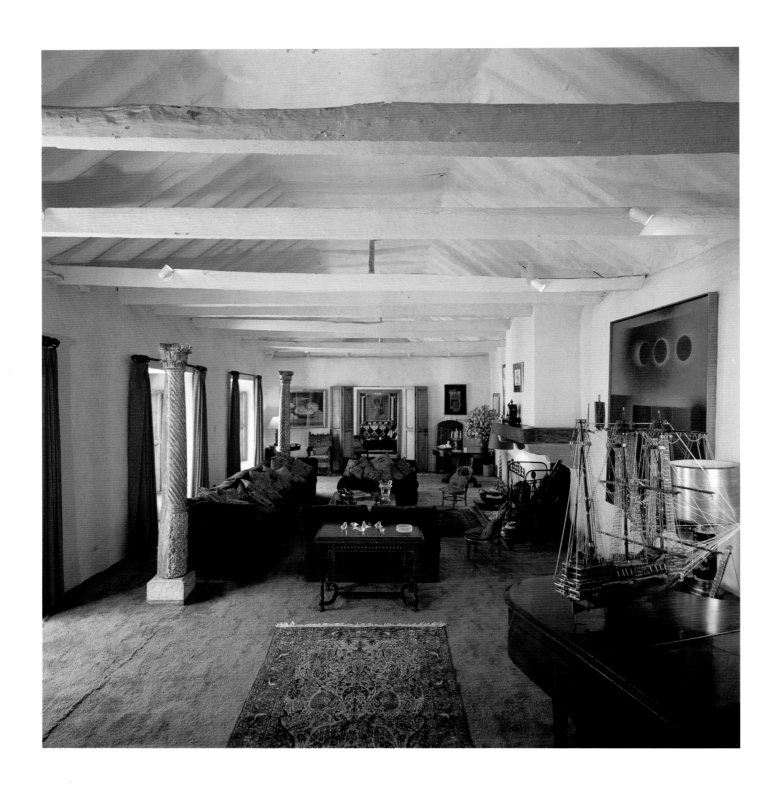

The house is the family's contribution to the perpetuation of tradition. In the house are manifested all the meanings, endeavors, longings, affections, dreams, and evocations that are the true history of a people. It is the master key that opens the way to the organization of society, to the modes of relationship and coexistence, to habits and customs, and to common and shared cultural interests. It expresses humankind's capacity to master the environment, to adapt it to its needs, and to make it the proper place for the expression of its ideals.

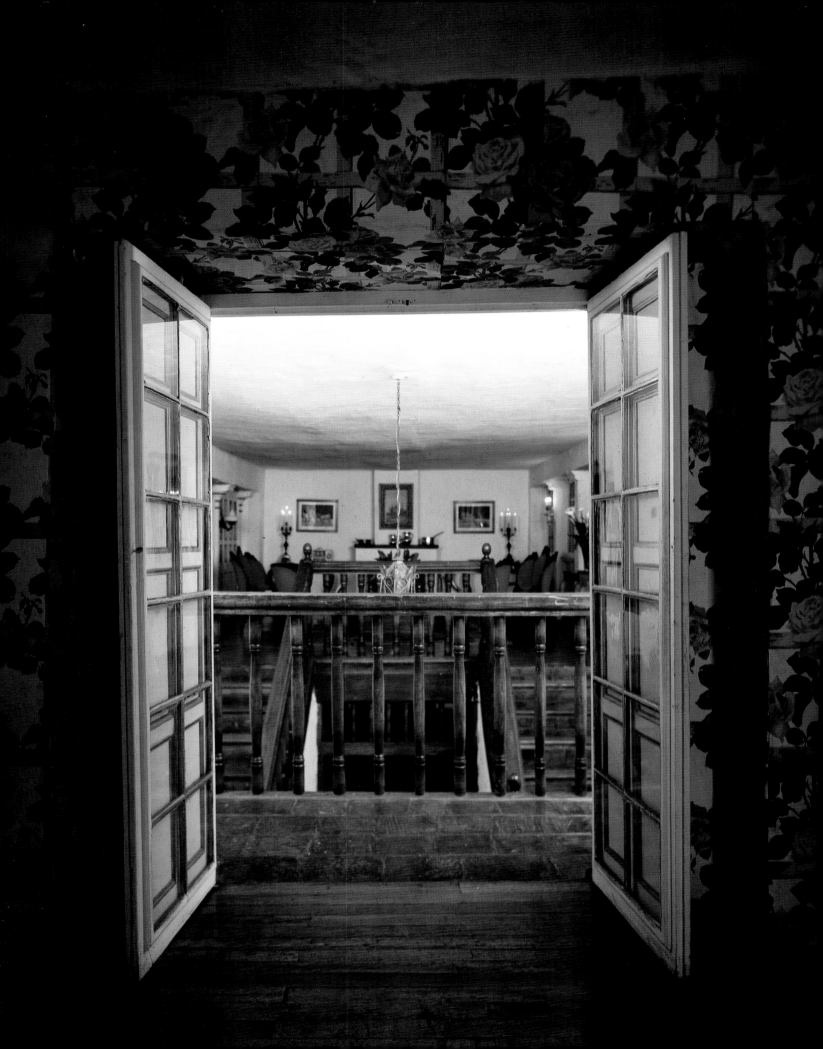

PHOTOGRAPHY CREDITS

Antonio Castañeda Buraglia

1, 14, 18, 19, 21, 22, 23, 24, 25, 26, 27, 28, 29, 30, 31, 32a, b, 33, 34, 35, 36, 37, 38, 39, 40, 41, 42a, b, 43, 44, 45, 48, 49, 50, 51, 52, 53, 54, 55, 56, 57, 58, 59, 61, 62, 66, 67a, b, 68, 69, 70, 71, 76, 77, 78, 79, 81, 82, 83, 86, 87, 88, 89, 92, 93, 96, 97, 107a, 114, 115, 118, 120, 121, 129, 130, 131, 132, 134a, b, 135, 136, 137, 138, 139, 140, 141, 142, 146, 147, 148, 149, 151, 153, 154, 155, 156, 157, 160, 161, 162, 163, 164, 165a, b, 167, 168, 170, 171, 172, 173, 174, 175, 176, 178, 179, 181, 184

Claudia Uribe

84, 85, 91, 98, 99, 100, 101, 102, 103, 104a, b, 105, 106, 107b, 108, 109, 110, 111, 112, 113, 116, 117, 119

Jose Fernando Machado

60, 73, 74, 75, 94, 122, 126, 127, 143, 144, 145, 152, 166, 177, 180

Hernan Diaz

46, 47

Pilar Gomez

158, 159

Diego Samper

80, 90

Fernando Correa

72, 169

Jorge Eduardo Arango

95